REDISCOVERING THE OLD TOKAIDO

Rediscovering

The Old Tokaido

IN THE FOOTSTEPS
OF HIROSHIGE

Patrick Carey

GLOBAL ORIENTAL

REDISCOVERING THE OLD TOKAIDO
IN THE FOOTSTEPS OF HIROSHIGE

First Published 2000 by
GLOBAL ORIENTAL
PO Box 219
Folkestone, Kent CT20 3LZ
England

Global Oriental is an imprint of Global Books Ltd

ISBN 1-901903-10-9

*The Publishers wish to thank the Great Britain
Sasakawa Foundation for their contribution in
the making of this book.*

British Library Cataloguing in Publication Data
A CIP catalogue entry for this book is available
from the British Library.

Printed in China

For
M.I.C.
C and C
and the teachers
and children
of Kanbe Shogakko

Contents

Furuki wo tazunete, atarashiki wo shiru

Foreword

AT THE END of the drive down to the main gate at my Hertfordshire boarding school there was a Roman road. It did not look Roman. This was the two-lane A10 from London to Cambridge. The Roman road, Ermine Street, was somewhere underneath the modern surface. Ermine Street went from Londinium to Eboracum via Lindum or, as we would say today, from London to York via Lincoln. For us it was the road south to the metropolis and home and freedom, though on Parents' Day it became for me the route for a short journey north to the university city. On these twice-termly outings I became familiar with the characteristic pattern of a Roman road: dead straight for four or five miles, then new bearings, followed by another dead straight stretch of similar length. On the Ordnance Survey map you could see places where the A10 deviated slightly, whereas the Roman road marched on ahead along farm tracks and, as a dotted line, across fields.

I used to fantasize about digging up these fields to lay bare the original Roman paving, and indeed near Puckeridge one could see the contours of a large mound where our Physics master conducted archaeological digs at the site of a Roman fort.

In Japan there are a number of roads that have a pedigree similar to that of Britain's Roman roads. The most famous of these was the Tokaido which ran from Edo (Tokyo), the shogun's capital, to Kyoto, the imperial capital. Unlike Ermine Street, which enjoys little fame in Britain today, the Tokaido forms part of the very fabric of Japanese culture and tradition. It was immortalized by poets and artists, and from medieval times until the present most of the significant events in Japanese history have occurred at one or other end of its route, or somewhere along it.

But now shoguns and the imperial court have given way to Prime Ministers and bureaucrats and the *salaryman,* and the area traversed by the Tokaido is today home to an industrial linear megalopolis with a GDP almost equal to that of Germany.

Could the ancient road have survived the last tumultuous one hundred years? This book is the account of a journey I made on foot to try to uncover what, if anything, remained of the Old Tokaido highway and of the fifty-three scenes along its way depicted by its most famous artist, Hiroshige.

My thanks are due to many, many people who contributed to the journey and its publication in book form. First of all, they are due to those I met on the way, some of whom are mentioned in

these pages, for their many kindnesses. Then there are the colleagues at the various institutions in Japan where I have worked, in particular ILC Tokyo and Reitaku University. They are too many to mention by name, but I must make an exception for Professor Keisuke Kawakubo, a constant source of expertise and encouragement, and Mr Hiroki Iwai who gave generously of his time at a crucial juncture.

I would like to thank the Tokyo National Museum for permission to reproduce their set of original Hoeido Tokaido woodblock prints, and Mr Haruo Nishimura and the *Mainichi Daily News*, in which an earlier version first appeared, for permission to re-publish.

Two people cannot be thanked enough: Paul Norbury for seeing the possibilities of the manuscript and for all the work he has done in designing and publishing the finished product, and my wife for just about everything.

For background information I have relied heavily on Kodansha's magnificent *Japan: An Illustrated Encyclopedia*. For any mistakes in my text I am, of course, solely responsible.

Publication of this book was assisted with a generous grant from the Great Britain-Sasakawa Foundation and I would like to express my gratitude to the foundation's boards in London and Tokyo and to Ms Setsuko Sengoku, Director of the foundation's Tokyo office.

I would like to express my gratitude to my brothers and sisters, brothers-in-law and sister-in-law, for helping me with advice, computers, fax machines and sustenance and, on one occasion in a Lake District cottage, for transcribing my appalling handwriting into a form that could be read by a secretary in Cockermouth for typing up and faxing to Tokyo.

And finally, my thanks to Adam Fulford whose initial encouragement got me writing; to Anthony Bryant and Margaret Price at the *Mainichi Daily News* whose patience and helpful editing kept me going; and to Chrystal and Merrick Baker-Bates for their hospitality and for first planting in my brain the idea of walking in the footsteps of Hiroshige.

PATRICK CAREY
TOKYO

Historical perspective

Japanese history is traditionally divided into convenient historical eras whose names are derived from the seat of government (Nara to Edo) or, in modern times, from the ceremonial name of the Emperor.

Era	Dates
Jomon	10, 000 BC - 300 BC
Yayoi	c300 BC - 300 AD
Kofun	c300 AD - 710
Nara	710 - 794
Heian	794 - 1185
Kamakura	1185 - 1333
Muromachi	1333 - 1568
Azuchi-Momoyama	1568 - 1600
Edo	1600 - 1868
Meiji	1868 - 1912
Taisho	1912 - 1926
Showa	1926 - 1989
Heisei	1989 -

(Source: derived from *Japan: An Illustrated Encyclopedia,* Kodansha)

Selected dates in Japanese history

552 Buddhism introduced to Japan (traditional date).

710 Capital city established at Nara.

794 Capital city moves to Heiankyo (Kyoto).

1192 Minamoto no Yoritomo appointed shogun by Emperor Go-Toba. The seat of government is now at Kamakura, near modern Tokyo. The Tokaido becomes the main route connecting the imperial capital of Kyoto with the military capital at Kamakura.

1338 Government of Japan moves back to the area of Kyoto with the establishment of the Muromachi Shogunate by Ashikaga Takauji. Eventually, unified government of Japan collapses and the country drifts into prolonged civil war.

1543 Matchlock muskets introduced into Japan by the Portuguese.

1549 Francis Xavier establishes the first Christian mission to Japan.

1575 Battle of Nagashino. Oda Nobunaga's use of firearms introduces modern warfare to Japan and assures his victory. Beginning of unification of Japan.

1590 Toyotomi Hideyoshi brings all Japan under centralized control. Sends Tokugawa Ieyasu to province of Musashi, where he sets up his headquarters in the fishing town of Edo.

1600 William Adams (English mariner) arrives in Japan.

_____ Battle of Sekigahara. Tokugawa Ieyasu becomes undisputed leader of Japan.

1601 The Tokaido highway is re-established.

1603 Tokugawa Ieyasu granted title of shogun. Establishes his shogunate at Edo (modern Tokyo). Re-establishes *sekisho* (check-points) on the Tokaido.

1635 Tokugawa shoguns adopt title of *taikun* (later to give rise to English word 'tycoon').

1635 Beginning of policy of National Seclusion. Japan is closed to all outside contact except restricted trade by the Chinese and Dutch.

1642 *Sankin kotai* rule established by which daimyo must spend alternate years in residence in Edo.

1689 Matsuo Basho begins his journey which he later describes in *Oku no Hosomichi (The Narrow Road to the Deep North).*

1691 Engelbert Kaempfer, German physician at the Dutch trading settlement in Nagasaki, travels along the Tokaido to Edo.

1703 Vendetta by the 47 ronin against Lord Kira.

1707 Most recent eruption of Mount Fuji.

1790 The Ukiyo-e artist Utamaro flourishing.

1797 Birth of Hiroshige.

1802 Jippensha Ikku publishes *Tokaidochu Hizakurige ('Shank's Mare').* Comic novel describing travels of two commoners on the Tokaido.

1831 Hokusai's Thirty-six Views of Mount Fuji.

1832 Hiroshige travels the Tokaido on a shogunate mission to the Emperor.

1833 Publication of Hiroshige's Fifty-three Stages of the Tokaido series of woodblock prints.

1853 Arrival at entrance to Edo Bay of Commodore Perry's fleet.

1854 Second visit by Perry's fleet.
 Treaty of Amity between USA and Japan signed.

1858 Death of Hiroshige.

1859 Japan opened to outside world for first time in over
 two hundred years.

1862 Richardson Affair.
 Abolition of *sankin kotai* (alternate attendance rule).

1863 Bombardment of Kagoshima by British warships in
 retaliation for murder of Richardson.

1868 Meiji Restoration.
 Edo re-named Tokyo ('Eastern Capital').

1869 Emperor removes to Tokyo.
 sekisho (check-points) abolished.

1871 Feudal domains dissolved. Prefectures established.

1893 Completion of Tokaido railway line. Many Tokaido
 post-stations lose their *raison d'être*.

1894-5 Sino-Japanese War.

1904-5 Russo-Japanese War.

1923 Tokyo earthquake.

1941 Japanese attack on Pearl Harbor. Pacific War begins.

1945 Japan surrenders. End of Pacific War.

1952 End of Occupation of Japan.

1964 High-speed Shinkansen ('bullet train') service
 between Tokyo and Osaka begins.

1989 Death of Emperor Showa (Hirohito)

1990 Enthronement of Emperor Akihito.

1995 Kobe earthquake

(Source: derived from Japan: *An Illustrated Encyclopedia, Kodansha*)

Translation of Hiroshige's sub-titles

Note: print numbers are provided for convenience. They do not feature in the actual prints. The convention followed here and elsewhere in this book is to give no number for Nihonbashi and Kyoto, the start and finish, and to number the stages 1–53.

Translations of the sub-titles are the author's.

 Nihonbashi: *Asa no kei* (Morning view)
1 **Shinagawa:** *Hinode* (Sunrise)
2 **Kawasaki:** *Rokugo watashibune* (Rokugo ferry)
3 **Kanagawa:** *Dai no kei* (Hilltop view)
4 **Hodogaya:** *Shinmachi bashi* (Shinmachi Bridge)
5 **Totsuka:** *Motomachi betsudou* (Motomachi fork)
6 **Fujisawa:** *Yugyoji* (Yugyoji temple)
7 **Hiratsuka:** *Nawate michi* (Path through rice fields)
8 **Oiso:** *Tora ga ame* (Tora's rain)
9 **Odawara:** *Sakawa gawa* (Sakawa River)
10 **Hakone:** *Kosui zu* (Lake view)
11 **Mishima:** *Asa giri* (Morning mist)
12 **Numazu:** *Tasogare zu* (Dusk scene)
13 **Hara:** *Asa no Fuji* (Fuji in the morning)
14 **Yoshiwara:** *Hidari Fuji* (Fuji on the left)
15 **Kanbara:** *Yoru no yuki* (Snow at night)
16 **Yui:** *Satta mine* (Satta peak)
17 **Okitsu:** *Okitsu gawa* (Okitsu River)
18 **Ejiri:** *Miho enbou* (Distant view of Miho)
19 **Fuchu:** *Abe gawa* (Abe River)
20 **Mariko:** *Meibutsu chamise* (Famous local delicacy tea-house)
21 **Okabe:** *Utsu no yama* (Utsu mountain)
22 **Fujieda:** *Jinba tsugitate* (Relay station for porters and horses)
23 **Shimada:** *Oi gawa Shungan* (Oi River Suruga bank)
24 **Kanaya:** *Oi gawa Engan* (Oi River Totomi bank)
25 **Nissaka:** *Sayo no Nakayama* (Sayo-amid-the-mountains)
26 **Kakegawa:** *Akibasan enbou* (View of Mount Akiba)
27 **Fukuroi:** *Dechaya no zu* (Outdoor tea-house scene)

Some features of a Hiroshige print

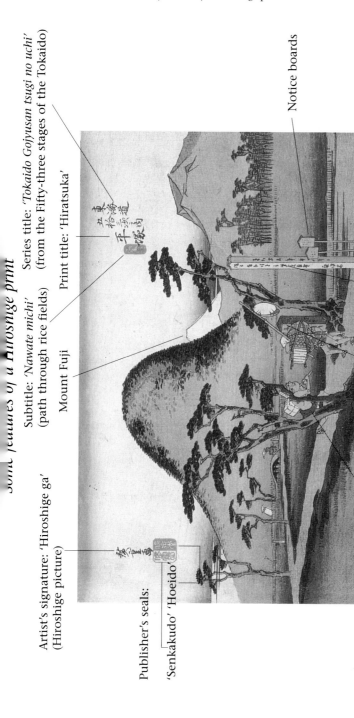

Series title: *'Tokaido Gojyusan tsugi no uchi'*
(from the Fifty-three stages of the Tokaido)

Subtitle: *'Nawate michi'*
(path through rice fields)

Print title: *'Hiratsuka'*

Mount Fuji

Notice boards

Bohana: tall pole marking limit of post-station area

Signpost

High-speed courier

Artist's signature: *'Hiroshige ga'*
(Hiroshige picture)

Publisher's seals:
'Senkakudo' 'Hoeido'

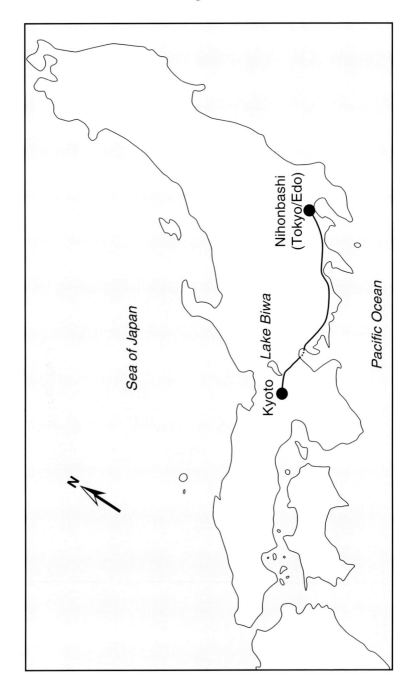

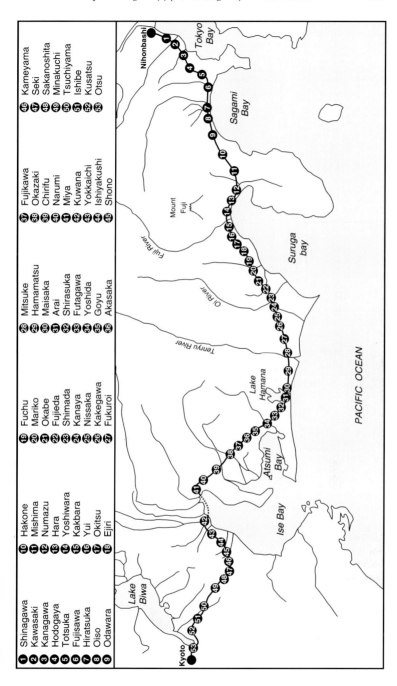

● Shinagawa
❶ Kawasaki
❷ Kanagawa
❸ Hodogaya
❹ Totsuka
❺ Fujisawa
❻ Hiratsuka
❼ Oiso
❽ Odawara

⓵ Hakone
⓫ Mishima
⓬ Numazu
⓭ Hara
⓮ Yoshiwara
⓯ Kakbara
⓰ Yui
⓱ Okitsu
⓲ Ejiri

⓳ Fuchu
⓴ Mariko
㉑ Okabe
㉒ Fujieda
㉓ Shimada
㉔ Kanaya
㉕ Nissaka
㉖ Kakegawa
㉗ Fukuroi

㉘ Mitsuke
㉙ Hamamatsu
㉚ Maisaka
㉛ Arai
㉜ Shirasuka
㉝ Futagawa
㉞ Yoshida
㉟ Goyu
㊱ Akasaka

㊲ Fujikawa
㊳ Okazaki
㊴ Chirifu
㊵ Narumi
㊶ Miya
㊷ Kuwana
㊸ Yokkaichi
㊹ Ishiyakushi
㊺ Shono

㊻ Kameyama
㊼ Seki
㊽ Sakanoshita
㊾ Minakuchi
㊿ Tsuchiyama
Ishibe
Kusatsu
Otsu

JAPANESE WORDS
For ease of reference, Japanese words appearing in the text are italicized, except those which have now entered the English language, such as shogun, samurai, daimyo, saké, sushi and haiku. (See Glossary on pp 138-142.)

HIROSHIGE PRINTS
The set of Hiroshige prints featured in this book were supplied by the Tokyo National Museum.

Introduction

IT WAS DAWN on a summer's morning of the year 1832, the second year of the Tempo era, as the small procession crossed the bridge over the last moat at the outer limit of the shogun's castle, passed the guard at the massive stone gate-house and headed for the Bridge of the Rising Sun. From there the procession would follow the Tokaido, the great highway that joined the shogun's capital Edo with the ancient imperial capital, Kyoto.

It was an official mission. The shogun was engaged in an act of ritual obeisance. The Emperor of Japan had for centuries been a figurehead. True power resided with the military, in the person of the shogun, the all-powerful ruler of feudal Japan. But appearances had to be maintained and he had chosen two fine horses and was sending them to the Emperor as a gift. The horses and their accompanying retinue would walk the 303 miles to Kyoto where they would be presented to His Majesty with due ceremony.

The road they would travel, the Tokaido, would cross a steep pass through the mountains to the west of the city and then follow the sea coast of Eastern Japan. Hence its name: *To* means east, *kai* means sea, and *do* is way or road. At one point it would actually pass through the sea, and here a ferry provided the link. Then, after crossing another mountain pass, it would enter the Kansai, the area 'west of the barrier', at the centre of which was Kyoto. The road started at a bridge, the Nihonbashi, which can be variously translated as the Bridge of Japan or the Bridge of the Rising Sun, and ended at a bridge, Sanjo Ohashi, the Great Sanjo Bridge.

Every country has its evocative road: a road that encapsulates that country's history, or that stirs the imagination with dreams of travel, romance, danger, discovery, adventure or escape: Chaucer's Pilgrims' Way, the Great North Road, the Appian Way echoing to the marching feet of Roman legions, the Silk Road from China, the Mormon Trail with its lines of covered wagons

crossing the plains of Nebraska, and in this century, Route 66 from Chicago to the Pacific Ocean at Los Angeles.

Such a road was the Tokaido. It first saw the light in the Nara era (710-794) when it was trodden by Buddhist monks spreading the newly imported religion to outlying areas that had known only the animist rites of Shinto. In the Heian era (794-1185) Buddhist temples along its route were required by government ordinance to set aside accommodations where travellers could find rest for the night. Then in the Kamakura era (1185-1327) when the Emperor in Kyoto lost the last semblance of real authority and a military ruler had set up what amounted to a rival capital, two hundred and seventy miles away to the east, it became the artery for feudalistic control of distant provinces, of which Kyoto was now one.

However, centralized control eventually broke down and during the Warring Provinces period of the sixteenth century the Tokaido was to fall into disuse, as civil war broke Japan up into many isolated, mutually hostile, domains. And so the chaos continued for one hundred years until in 1601 a warlord of legendary patience finally established total dominance over the whole country. His name was Tokugawa Ieyasu and his fief was Edo. He is more familiar, perhaps, as the Toranaga of James Clavell's novel *Shogun*.

For the next two hundred-and-fifty years there was peace and his dynasty would rule unoppposed. And the Tokaido would play a significant role in the strategy that made the peace possible.

Ieyasu made the Tokaido the main link between his military and administrative capital, Edo (now Tokyo), and Kyoto, the spiritual capital where the figurehead ruler, the divinely-descended Emperor, held court in his city of temples and shrines, priests and monks. By extension, the Tokaido also connected with the commercial capital Osaka. To facilitate travel down this key artery Ieyasu decreed the establishment of fifty-three post-towns. Here transportation offices controlled relays of horses, palanquins, porters and messengers. Meanwhile, some of these towns already functioned as the castle-town of a feudal domain.

There were some two hundred-and-fifty of these feudal domains in Japan and any one of the daimyo (feudal lords) could mount a threat to Ieyasu's paramount rule. The shogun made that less likely by insisting that the daimyo maintain dwellings in Edo.

There their wives and families would live as virtual hostages of the shogun; they themselves would have to live alternately in Edo and in their own domain. By this system of *sankin kotai* (alternate attendance) the daimyo spent vast amounts of time and money journeying to the capital, resources that might otherwise have been used in organizing rebellion against the shogun.

Perhaps one hundred-and-fifty of these feudal lords used the Tokaido to travel to and from Edo, with retinues of anything from three hundred to several thousand men. The daimyo and higher-ranking samurai would spend the night at the *honjin,* the official government accommodation, while the rest of the retinue would find food and lodging at one of up to two hundred privately-owned inns.

But the Tokaido was not just for the military caste. It was also a commercial route and a pilgrims' way. Rice, saké and green tea were transported. Pilgrims travelled to visit famous monasteries and to pray at the Grand Shrines of Ise, either as individuals representing their community or in mass migrations. In the spring of 1705, sensing some coming apocalyptic event, hundreds of thousands rushed from their towns and villages to make their way by the Tokaido to Ise: three thousand children in just one morning before dawn; in six weeks over three million pilgrims.

But on that summer's morning in 1832 the Tokaido was merely busy. One of the members of the group was an artist. He had recently become known for his sketches of famous places in Edo, but he had always wanted to see for himself the famed sights of the Tokaido. He had once been a junior officer in the shogun's fire-brigade, with responsibility for Edo castle, a position he had inherited from his father and from which he had resigned in order to devote more time to print design. It was not too difficult for him to use his castle connections to obtain a place on the Kyoto-bound mission. His name was Ando Hiroshige. His art was that of the woodblock print. He would use this journey to produce sketches from which a woodblock carving would be made. The block would then be used by a skilled artisan printer to produce tens of thousands of colour prints.

The resulting series of prints were both revolutionary and an instant popular success. Hiroshige sketched each of the fifty-three post-stations and published the resulting colour prints as 'The

Fifty-three Stages (or stations) of the Tokaido', *(Tokaido no Gojyu San Tsugi)*. In actual fact, there are fifty-five prints, since there is also one for the starting point in Edo and one for the goal, Kyoto.

They were revolutionary because, unlike the stylized landscapes that showed imaginary scenes depicted according to the conventions of the Chinese schools, these were drawn straight from nature. Chinese landscapes were dignified and remote from daily life; Hiroshige's landscapes included ordinary human beings going about their daily occupations: palanquin bearers, shopkeepers, blind pilgrims, boatmen, inn servants, strolling players. And they were down to earth and often humorous: a maid at an inn inspecting the blisters on the feet of a traveller who has just checked in, other maids (prostitutes really) tugging at the sleeves of passing travellers in order to persuade them to stay. And they were irreverent: the shogun's horses, the gift to the Emperor, do not figure until near the end of the journey and even then they are not the focus of the print; daimyo and samurai rarely appear and when they do they are overshadowed by the majesty of the scenery; and in the very first print in the series, two dogs turn their backsides to a departing daimyo procession.

The Tokaido was already famous when Hiroshige travelled and sketched it. But it was his print series, The Fifty-three Stages of the Tokaido, that immortalized it, not only for contemporary and future Japanese, but also for lovers of Japan and Japanese prints everywhere. Two decades after he completed the series Japan was opened up to world trade following two hundred-and-thirty years of near total seclusion, decreed back in the early seventeenth century in order to keep Japan safe from the proselytizing Christians and from the European empire-builders.

From 1859 foreign traders and diplomats flooded into Japan. The Tokugawa shogunate was revealed as symbolic of a weak and backward nation. Yoshinobu, the last of the dynasty, resigned and the Emperor Meiji travelled along the Tokaido to Edo which he renamed Tokyo or 'Eastern Capital', in contrast to the former capital Kyoto which was situated to the west. And that imperial journey was to signal the end of the great highway and the scenes that Hiroshige had depicted. An official policy of modernizatiion and Westernization, brought first railways then tarmac road surfaces; the Tokaido became redundant and

eventually with road widening and the advent of expressways and high-speed rail links, it became unrecognizable. Meanwhile earthquakes, bombardment by B29 Flying Fortresses, and the post-war scramble for economic success did the rest. The old Tokaido road and its much loved Hiroshige scenes were first forgotten and then lost forever.

Not that that mattered to me when I first came to Japan on a one-year contract, attracted more by a desire to participate in its economic success than by its history and culture. The name Hiroshige was vaguely familiar but I had never heard of the Tokaido. But both names cropped up in my reading during a hectic orientation week.

Not long afterwards, I was at a party and had asked for suggestions for targets to aim at during my year here. 'What you really should do is walk the fifty-three stages of the Tokaido'. It sounded a fun idea at the time but by the following morning, my initial enthusiasm had faded. There seemed little point in exploring a three-hundred-mile industrial belt by trudging from Tokyo to Kyoto down the noisy four-lane modern highway that had obliterated almost all trace of Japan's most famous road.

But the urge to see for myself persisted, to prove something by walking every step of the way that the poet Basho, Hiroshige, daimyo, countless couriers of the shoguns, and the Emperor Meiji himself had travelled, to punish myself by witnessing close-up the pollution and outright destruction of the landscape that I had seen as a blur from the windows of the bullet train and perhaps — who knows, just perhaps — to find a forgotten stretch of the original road, marooned, cut off like an ox-bow lake, as the twentieth-century contractors bulldozed away over four hundred years of history.

And then one day, browsing among the second-hand book shops of Tokyo's Jimbocho district, I came across a small book called *'Tokaido no Gojyusan Tsugi'* (The Fifty-three Stages of the Tokaido). The Japanese text was beyond me, but the maps were intriguing: there were about twenty of them and they indicated the path of Route 1, the modern road from Tokyo to Kyoto. Roughly parallel to this ran two sets of railway tracks: the Japan Railways main line and the high-speed line of the bullet train (Shinkansen); and then came the Expressway. These four modern equivalents of the Edo period route vied for what little

space there was between the mountains and the sea.

Then I saw that there was another line, which at first I took to be a river or a boundary of some sort. Sometimes it branched off from Route One and rejoined it later, sometimes it ran independently. Beside this thin line were the Chinese characters for *'Kyu Tokaido'*, Old Tokaido. Did this mean the original road was still there? The book had been published in 1975, but was the author merely indicating where the old road had once run?

I checked with several Japanese and foreign acquaintances but they all said there was nothing left of the Old Tokaido except for a well-known section at the tourist resort of Hakone and one or two post–towns near Nagoya. I looked up the *Encyclopedia of Japan* and found confirmation of this dismal news. So that was that. It had all been swept away in a mad rush of twentieth-century modernization.

There still remained, however, the challenge of trying to identify the present-day sites of the landscapes in Hiroshige's wood-block prints. And to walk from Nihonbashi, the traditional starting point, to Yokohama, where I lived, might give me some idea of what the journey had been like for travellers during the Edo period. So, one Sunday morning in May, I made my way to the bridge at Nihonbashi, armed with a map photocopied from the book I had found in Jimbocho, and with a pocket-sized edition of Hiroshige's *Fifty-three Stages of the Tokaido.*

I would try to cover the first three or four stages and see what I could find along the way. The names of the post-towns seemed to come straight from a Japan Railways timetable: Shinagawa, Kawasaki, Kanagawa, Hodogaya... I set off at 10.45 am down the Ginza main street. A predictable series of department stores, banks and shops gradually gave way to nondescript square concrete structures at Shinbashi, followed by modern plate-glass office buildings at Mita, and then big international hotels at Shinagawa. The road here was busy and noisy, four lanes of heavy traffic in both directions.

Just after the Shinagawa Prince Hotel there is an outcrop about fifty feet high, dropping straight down to the road. This could be a candidate for a Hiroshige print that shows a steep slope on the right-hand side, a row of shops in the middle and fishing boats in the bay on the left. In fact, as this is the only steep slope that abuts onto the road, I felt I had made my first positive

identification.

(I was mistaken. I later learnt that the original hill in Hiroshige's print had been carted off to make a landfill in Tokyo Bay.)

Landfills have changed the scene almost beyond recognition, but I wanted to get nearer to where the shore had been in Hiroshige's time. I was at the point where the Old Tokaido was marked on my map. I left the main road, crossed the bridge over the railway line and found myself looking at a sign pointing down a narrowish road to the right. *'Kyu Tokaido,'* (Old Tokaido), it said.

The Edo period road, according to the *Encyclopedia of Japan*, was typically eighteen feet in width. I stood against a wall and strode carefully across. Exactly six paces.

That day I walked all the way to Yokohama, about eighteen miles, reaching the railway station area at 7.00 pm. About half my journey had been on the Old Road. The road did still exist. It was quiet; it meandered; it went past the entrances to ancient shrines and temples. At the point where it rejoined the traffic at Omori there was a sign marking the spot of the Suzugamori execution ground. Here, in the not-so-distant past the bodies of criminals had hung until they rotted. Somewhere along this road I had missed the site at Namamugi where in the nineteenth-century samurai had caused an international incident by killing a European trader. But it did not matter. I had seen enough to know I would be back, and that I would try to walk all the way to Kyoto.

1

From the shogun's capital

Nihonbashi • Shinagawa • Kawasaki • Kanagawa

'A journey of a thousand miles begins with a single step'

MY PROPOSED journey was 303 miles and the first step was taken at 9.20 am on a fine Wednesday morning in early September. The Tokaido starts at Nihonbashi, the Bridge of the Rising Sun. Hiroshige's hump-backed wooden structure, over a waterway connecting the bay with the moats surrounding Edo Castle, has given way to a modern stone bridge whose distinction was cast into gloom by the concrete of an overhead expressway. I had approached the famous bridge from a station on the north side. I had myself photographed next to a stone pillar with the bridge's name inscribed in *kanji*, Chinese characters, and observed the stone tablet that marks the zero point

NIHONBASHI In 1604, Nihonbashi Bridge was established as a central reference point to determine distances throughout Japan. It was the starting point for the Tokaido and four other roads radiating from Edo. Long-distance journeys such as this daimyo procession started at dawn.

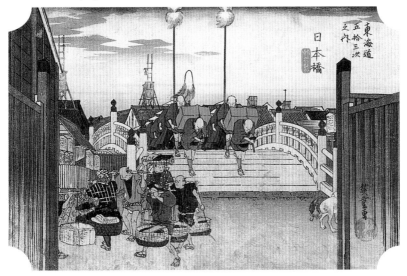

from which all road distances in Japan are measured and
checked the distance to Kyoto – 503 kilometres. I said
goodbye to my wife, crossed the murky waters of the
Nihonbashi River, and set off down the Ginza main street
past Takashimaya department store, past the up-market
Meidi-ya food shop and Matsuya department store,
reaching the Ginza 4-chome crossing (Tokyo's Piccadilly
Circus) just as the landmark Wako clock, a survivor of
World War Two, struck ten.

This was a pretty poor start. As soon as I got into a stride
I was held up by traffic-lights at each corner and by a
compulsive urge to photograph everything in sight, with
the result that by the time I arrived at Shinbashi, just a mile
or so down the road, I had already finished a roll of film and
deposited it for development. Mundane, hitherto unnoticed,
objects demanded attention. Police boxes, (miniature) road-
side police stations, are such a familiar sight in Japan that I
had long taken them for granted. I had thought they were
all the same: just that, boxes. In fact, I counted five different
styles between Nihonbashi and Shinagawa, from ivy-clad
pre-war ones to stainless steel state-of-the-art ones. I reached
Shinbashi at 10.40 am. Here the elegance of the Ginza gives
way to the ordinary. I had felt out of place in my walking kit

SHINAGAWA Having set out early morning, the daimyo's entourage would
reach Shinagawa, the first stage of the Tokaido, after walking two *ri* - just under
5 miles (7.8 k). A two-hour journey then, today eight minutes by train on the
main line that runs parallel to the road.

1

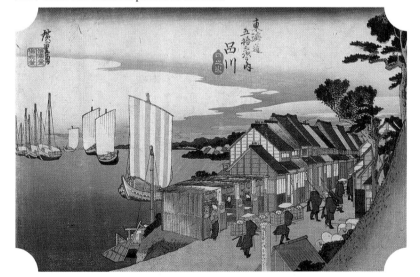

amongst the smartly dressed shoppers. Now I could relax a little. Already I had noticed one difference compared with London's West End. There was not one scrap of litter all the way from Nihonbashi to Shinbashi, no black plastic refuse bags and indeed no litter bins.

The distance to Shinagawa, the first of the fifty-three stages of the Tokaido, is two *ri*. A *ri* was the distance a man could travel in one hour with a load on his back. It was in common use as a unit of distance until 1959, when metrication became official. It would be a convenient unit for me because I had a list of the Tokaido post-towns and the number of *ri* between them and I would be able to calculate how long each section would take. Nevertheless, by the time I reached Shinagawa railway station at mid-day I was already an hour behind schedule. The streets were full of office workers, men in suits, women in uniform, on their way to lunch. Many were already lining up at the McDonald's opposite the station.

In the Edo period, travellers started out before dawn and would have reached Shinagawa by 6.00 am, with a first night stop at Hodogaya, the fourth stage, or Totsuka, the fifth. My target for this first night was the third stage, Kanagawa.

KAWASAKI The first ferryboat–crossing, over the Rokugo (Tama) River. Mount
2 Fuji appears for the first time, on the far right, and in today's landscape it is the
only surviving feature of this print.

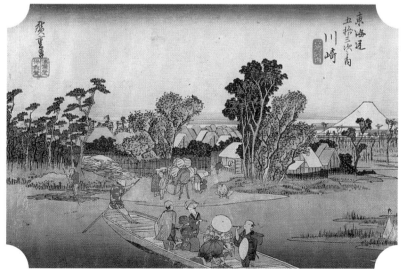

Just after Shinagawa station there is a bridge on the left-hand side over the main railway line. The main road, six noisy lanes of it, continues ahead, but across the bridge is a small road, some eighteen feet wide: this is the Old Tokaido. It is asphalted, of course, and the inns and teahouses of the Edo of *ukiyoe* prints have long gone out of business or been destroyed by natural or man-made disasters; but as you stand in the middle of the road (cars do came this way, but not many) and look down its length until it meanders out of sight, this road feels different.

A sign at the side of the road says *'Kyu Tokaido'* in *kanji* and Roman letters. *'Kyu'* means 'old,' or 'former,' and the Chinese character distinguishes the genuine article from the modern, characterless, polluted Tokaido (as it is still called) I had just left.

KANAGAWA This stage is now the area tucked away in obscurity behind Yokohama station. Remarkably, the actual road scene today (author in the foreground) chimes closely with Hiroshige's print.

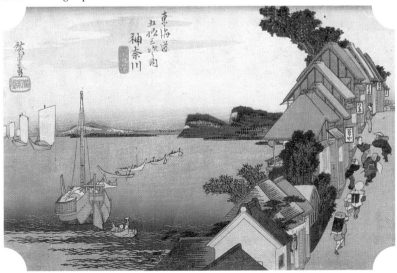

In the Edo period (1600-1868) this road meandered on beyond that corner at the limit of my sight, all the way to Kyoto. How far did it go today? I knew that at least occasional stretches existed between here and Yokohama, but beyond that? The only way to find out was to walk it and see.

First, however, I wanted to explore a little garden I had spotted next to the railway line. This turned out to be a miniature version of the fifty-three stages of the Tokaido: a path lined at short intervals with stone markers bearing the names of all the post-towns and winding its way past a three-foot-high grass mound representing Mount Fuji. I strolled along trying to familiarize myself with the strange names, past Ejiri, Fuchu, Mariko, Yoshida, Sakanoshita – I had never heard of any of them; did they still exist today? – until I come to the stone marked Kyoto. The fifty-three stages walked in as many seconds. Vicarious travellers could opt to call it a day and head back to McDonald's for lunch.

For my own picnic lunch, I bought some take-away sushi, a can of beer and a huge apple, twice the size of an English apple, hoping to find a suitable place to eat it further along. Judging from Hiroshige's print of Shinagawa I was now right

HODOGAYA Palanquin *(kago)* bearers cross a wooden bridge leading to a cluster of buildings in a rural setting. A group of monks approaches. The shop on the left sells soba noodles for 16 *mon* – the price of a Hiroshige print. Today this scene is hard to recognize. The river itself has been re-channelled and the bridge is concrete.

4

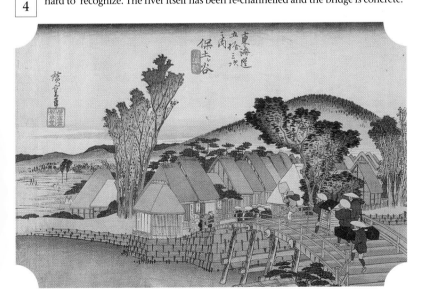

next to the bay that he shows behind a row of shops, but because of landfills there is little sign of water today. Eventually, there was a short road leading off to the left and ending in an embankment. I explored and found a wide channel, empty except for a few small boats, and with factories on the reclaimed land on the far side. There was nowhere but concrete to sit and no shade from the very hot sun, but I was ravenous and sat down by the waterside and started lunch.

A woman walked by with her dog. A man in his early forties in blue trousers and a white open-neck shirt approached and sat down about ten yards away. We got to talking and he came over and joined me. I offered him some sushi. He declined but accepted a slice of apple. He was

TOTSUKA A traveller dismounts and is greeted outside an inn festooned with nameboards of religious organizations making pilgrimages. Similar boards can be seen in modern hotels when groups are staying. Today the stone signpost ('Kamakura to the left') has gone but a display board a few yards away shows the Hiroshige print as confirmation that this is indeed the original site.

5

good-looking, with a two-day stubble and a lost look in his eyes. He was a construction worker, he told me, but was unemployed. When I told him about my plan to walk the Tokaido all the way to Kyoto and photograph the Hiroshige views he showed no surprise but told me to look out for the former execution ground at Suzugamori. Afterwards, he walked with me for ten minutes down the old road. We shook hands and said goodbye, but then he told me to wait while he suddenly disappeared into a shop. He came out with two rolls of color film which he thrust into my hand.

The execution ground is marked by a cluster of stone pillars and explanatory notice-boards at the junction of the old road and the modern Tokaido (Route 15 over this section). Travellers arriving at Edo were greeted with the sight of criminals tied to crosses and left to die, after which their severed heads were left on poles for three days, with a written account of their crimes attached.

I was back on Route 15 with the roar of heavy traffic. According to my map there was nothing left of the old road until after Kawasaki station, seven or eight kilometres of grind and exhaust fumes away. But after only a few hundred metres I saw ahead a small road peeling off to

FUJISAWA The most prominent feature of the print is the *torii* gate to Enoshima Shinto shrine in the foreground, yet the print sub-title names the Buddhist temple on the hill in the background, top right. Four blind pilgrims turn off the Tokaido to go to the shrine.

6

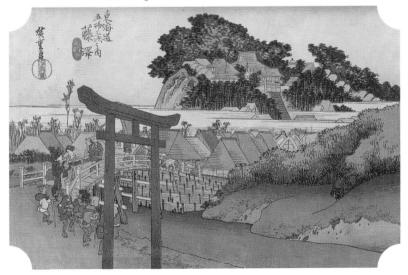

the left of a police box. A policeman stood outside, feet wide apart, a long riot-stick held out at arm's length at an angle from his body.

'Is that the Old Tokaido?' I asked.

The policeman nodded.

'*So desu*. Yes, it is.'

This turned out to be a section cherished by the local authority. Down both sides of the street were low stone slabs, on the flat tops of which were old maps and scenes from the heyday of the Tokaido. After ten pleasant minutes walking this section, busy with schoolchildren riding homewards on bicycles, I had to join Route 15 again and from that point until the Tama River I could find no further trace of the old road.

HIRATSUKA A high-speed courier heads past Mount Koma on the way to Edo, while two exhausted *kago* bearers plod slowly homewards having deposited their passenger. Mount Koma still dominates but no contemporary scene is complete without utility poles and a cat's-cradle of power cables.

7

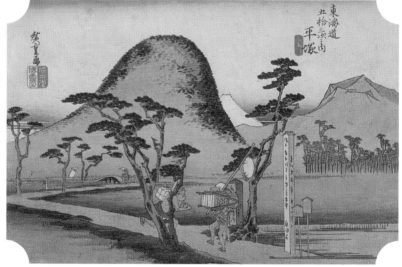

I was looking forward to trying to identify Hiroshige's viewpoint for his print of the Rokugo ferry at Kawasaki. The print shows a ferry boat about to make land on the Kawasaki side of the river; the road continues between a cluster of trees and thatched roofs, and Mount Fuji can be seen in the distance on the far right. I tried to sketch the scene from the Tokyo end of the modern steel bridge but could make no sense of the mass of girders, enormous road signs, tall lamp-standards and the clutter of large, featureless buildings on the opposite bank. And due to mist there was no Mount Fuji visible to help confirm the viewpoint. As I sketched, a mother and her eight-year-old daughter came by on their bikes.

'What are you doing?' the mother asked me with a perplexed smile.

'I'm walking to Kyoto,' I told her, 'and sketching the fifty-three stages of the Tokaido as I go.'

She looked at me in amazement. No one today was doing the five-minute walk across the bridge, let alone the 484 kilometres beyond.

On the far side of the bridge on the left, I found a marble block with a bas-relief in copper of the old ferry. According to my map I had to walk another two kilometres to pick up

OISO The rain is significant. The print's subtitle is 'Tora's rain', Tora being a serving maid and the rain being her tears. She retired heartbroken to a nearby nunnery when her lover committed *seppuku*.

8

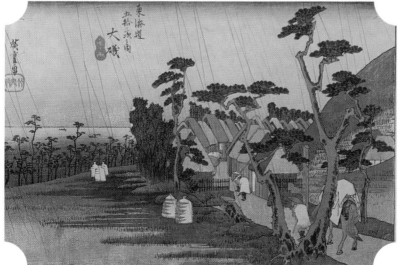

the old road on the right-hand side, so I walked through a dingy tunnel under the ramp to the bridge to reach the other side of Route 15. Here, to my surprise and delight, I found a quiet side road and a notice-board with a map of the Old Tokaido. Simple and attractive markers with pictures of different aspects of Kawasaki post-town were repeated every fifty metres or so as far as Kawasaki station. In every other respect, the old road was typical of modern Kawasaki: the pink neon lights on the roofs of short-stay love hotels, pachinko parlours – Japan's pin-ball machine gambling dens with their incessant clatter of metal balls falling into slots against a background of American marching music – and, as I passed a karaoke bar, the slightly out-of-tune drone of a salaryman singing an *enka*, folk song.

At Hatchonawate station, the old road turns right over a level-crossing, then sharp left, parallel to the tracks of the Keihin Kyuko railway. It then crosses the Tsurumi River and on the far side of the bridge it disappears into a group of trees and old houses. For a brief fifty metres, amidst the clamour of the cicadas, I was taken back a hundred years.

One of the less pleasant aspects of today's Japan are the activities of the extreme right, vociferous leftovers of Japan's militaristic past, allied to and often indistinguishable from,

ODAWARA On the other side of the Sakawa River a castle can be seen at the foot of the hills, top right. Odawara is the first of several castle towns on the way to Kyoto. A rebuilt keep is all that remains today. Odawara City is a stop on the bullet train line.

9

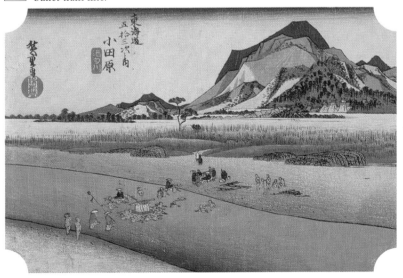

the organized gangsters, the *yakuza*. They drive slowly round urban areas, in large menacing 'sound trucks', blasting out their propaganda. Near Tsurumi Station, a pleasant-looking thug wearing a paramilitary uniform stopped his dark blue sound-truck at a traffic signal, martial music blaring from two monster loud-speakers. I approached the driver's window and asked him what organization he represented. He obligingly turned down the volume and told me, in a gruff staccato, that he was demanding the return of the Northern Territories, the islands north of Hokkaido occupied by the Soviet Union in the final days of World War Two.

'And what's the name of that marching song you're playing now?'

HAKONE Hiroshige's dramatic depiction of the Hakone mountains is contrasted with the daimyo's entourage descending like a column of ants. This is one of several in the series where the field of view is an astonishingly wide angle (well over 100 degrees horizontal). Hiroshige achieves this effect by compressing the mountain in the centre into a towering peak. A paved section of the old road, roughly bottom left in the print, is popular today with tourists. **10**

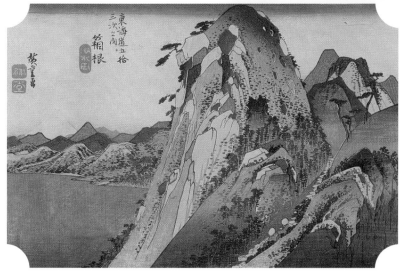

He smiled sheepishly.

'I don't know,' he said.

At Tsurumi Station the road goes diagonally under the tracks and continues through one of the ubiquitous archways that identify the street as a 'Shopping Ginza', or Main Street. It took a lot of identifying. A group of schoolboys wanted to send me to the main Yokohama road, also known as the Tokaido.

'But I'm looking for the Old Tokaido.'

Shopkeepers drew in sharp hissing breaths and shook their heads, but a young man on a bicycle confirmed the route. He was a zoologist and worked at a zoo in Yokohama. He had been doing what I was doing but following the old road in the opposite direction. He got off his bike and kept

MISHIMA Palanquin bearers, horse and rider emerge from the morning mist as they pass the *torii* gateway to Mishima Shrine. This is the point where Townsend Harris, the first American envoy to Japan, joined the Tokaido, on his journey from Shimoda to meet the shogun. Today, Route 22.

11

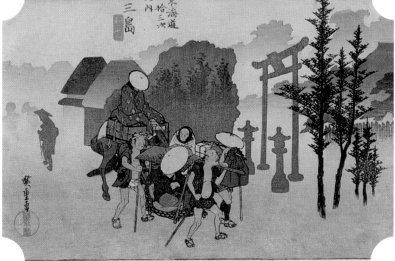

me company for forty-five minutes. I was in good hands.

After five minutes the old road ended abruptly where the four lanes of Route 15 sliced brutally through, but there on the other side, making exactly the same sharp exit angle, it continued as if nothing had happened. We went on and shortly afterwards passed through the middle of a funeral wake, the whole street forming an open-air funeral parlor, with black-and-white awnings and mourners lining up at tables to present their special gift-money envelopes. (Japanese homes are so small that a ceremony such as a wake will often overflow into public space.) Then on past the Kirin brewery and to the junction with the main road where I knew I would find the little enclosure, easily missed, on the left-hand side, just before the railway bridge, that marks the site of the infamous Namamugi Incident.

On a September morning in 1862, three Englishmen and a lady were out for a day's ride in the countryside. Japan had opened its doors to trade in 1859 and these foreigners, based in Yokohama, were among the first foreigners to set foot in Japan in over two hundred years (other than the Dutch and Chinese, confined to an island in Nagasaki harbour). As they proceeded in the direction of Edo, they met an on-coming *daimyo gyoretsu*, the procession of a feudal lord, in

NUMAZU A pilgrim bound for Kompira Shrine walks beside the Kano river, carrying a mask of the long-nosed goblin Tengu. The mask will be a votive offering to the Kompira Shrine. For the Japanese, the full moon will be a harvest moon, code for autumn.

12

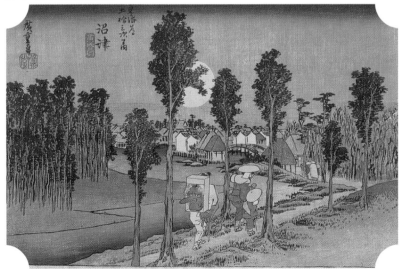

this case, that of Shimazu Hisamitsu, the *de facto* daimyo of the Satsuma fief. It was an imposing sight, and no doubt the party of foreigners was understandably curious.

Accounts of what happened next vary: that the foreigners turned back; that they dutifully stepped aside; that Charles Richardson, from Shanghai, rode alongside the palanquin and tried to look inside. What is certain is that a number of Shimazu's samurai drew their swords and hacked at the party. Two were wounded, the lady lost her flowing hair, and Richardson was left dying by the roadside, as the survivors obeyed his cry that they flee.

Richardson, being a visitor – the others were residents – perhaps did not know the appropriate etiquette when encountering a daimyo train. He was not to know that

HARA At last, some 80 miles from Edo, Mount Fuji comes into full close-up view. Hiroshige emphasizes its height by allowing its peak to break through the top edge of the woodblock frame. Today's picture was taken at a point near Hara where the Tokaido runs close to the sea.

13

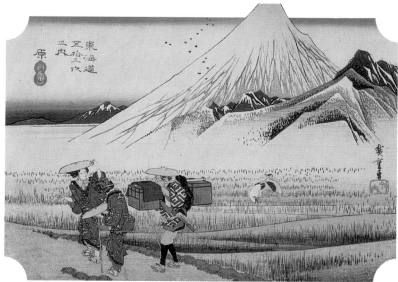

Shimazu was no lover of the treaties that had allowed foreigners into Japan. Shimazu's men would not have known that the prime minister of Richardson's country was the same Palmerston who had a few years earlier made the speech in the House of Commons that had started the era of gunboat diplomacy. 'As the Roman, in days of old, held himself free from indignity, – when he could say *Civis Romanus sum*, – so also a British subject, in whatever land he may be, shall feel confident that the watchful eye and the strong arm of England will protect him against injustice and wrong.'

Revenge for the incident was taken eleven months later when a combined British and French fleet bombarded Kagoshima, the Satsuma capital. But the British, who had expected a pushover, were taken aback by the tenacity and accuracy of the countershelling. Sixty Britons were killed. Shimazu`s elder brother had eight years previously completed Japan's first reverberating furnace needed for producing heavy artillery, and the first Western-style factory for the production of gunpowder. A British ship was hit just as it sailed into the area the Satsuma batteries had been using for target practice.

Richardson's body was taken to the American consulate

YOSHIWARA Three riders on one horse (*sampokojin*) ride between a row of pine trees that line the route. At least one of the riders has noticed that Mount Fuji, until now always visible on the right, has suddenly appeared on the left-hand side, due to the kink in the road. The print's subtitle means 'Fuji on the left'.

14

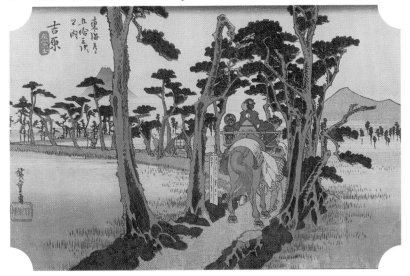

in Kanagawa, a couple of miles away, and was buried in the foreign cemetery at Yokohama, in a grave at the foot of 'The Bluff'. Visitors today will find flowers on his grave. They are placed there by the owner of a liquor store in Namamugi. When on a previous occasion I had been looking for the site of the incident, I had dropped in at his shop, which I had chosen at random, to ask for information. He not only showed me where the attack had taken place, but also the place further on where Richardson's body was found. He has built up a large collection of memorabilia relating to the incident, including a graphic account in an 1862 copy of the *Illustrated London News*. He visits Richardson's grave every year on the anniversary of his death.

As I continued my journey towards Yokohama, I tried to re-create the scene and to imagine the feelings of Richardson's companions as they fled in panic towards the safety of the consulate in Kanagawa. But huge trucks roared past in an unending stream of exhaust fumes, and I could think only of my own blisters which had started to cause trouble at Kawasaki and which were now agonizingly painful, and I also noticed that an old skiing injury in my knee was flaring up and making it difficult to walk.

Just opposite a small park near Yokohama Sogo

KAMBARA Continuing his occasional seasonal theme, Hiroshige creates a wintry scene for this little post-town. In actual fact, snow is rare in the Mediterranean climate of Suruga Bay and today the town is better known for the smelting of aluminium.

15

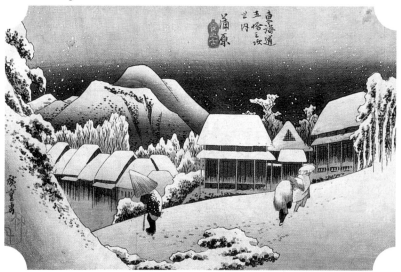

department store a narrow road leads off to the right under a shopping street arch. It was the old road again. I went on past Kanagawa station, crossed the railway bridge with its panoramic views of what was once beach, bay and fishing boats, and is now the vast sprawling complex consisting of Yokohama station and five department stores including Sogo, the largest department store in Asia. High above me on the right I could see Hongakuji, the temple that once housed the American consulate and to which Richardson's bloody corpse had been taken.

Here I left the Old Tokaido and wandered through the maze of backstreets and filthy canals to the longed-for luxury of the Rich Hotel, where the bathroom was to be almost the size of the *apato*, the small standard Japanese wooden apartment, in which I had once lived. So far, at least, my journey had not been wasted.

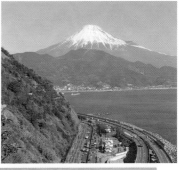

YUI Hiroshige's travellers are torn between their admiration of the stunning beauty of the view and their fear of the almost precipitous drop to the blue-green waters of Suruga Bay. Today's photograph was taken close to where Hiroshige stood to sketch the scene. [Photo: Tsuchida Hiromi]

16

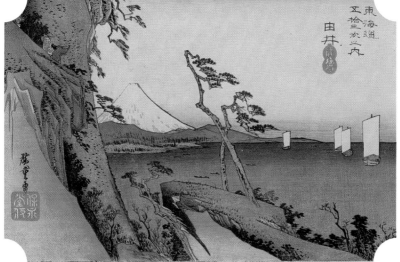

2

From Musashi to the province of Sagami

Kanagawa • Hodogaya • Totsuka • Fujisawa • Hiratsuka • Oiso

I HAVE DIFFICULTY leaving hotels. Breakfast is my favourite meal. Doing the journey by map over coffee helped postpone the painful reality of having to hit the road once again. It had taken half an hour to tend to my blisters and get into my shoes over an extra pair of thick woollen socks. I could see before starting that I had miscalculated my next overnight stop. I had been invited for dinner and offered a bed for the night by a Japanese couple in Oiso. Yesterday I had covered seven *ri*, by definition a seven-hour journey. Today's distance was about nine *ri* (36 km): if I walked flat out I might be able to get there by 9.00 pm.

It was 10.30 am by the time I was back at the spot where I had left the old Tokaido the night before. I was at the foot

OKITSU Sumo wrestlers are carried across the Okitsu River by horse and palanquin. Four bearers are required in order to carry this passenger, compared with only two at Mishima. Okitsu is where the last of the *genro*, Prince Saionji (1849-1940), lived and died. His house faced the Tokaido on one side and the sea on the other.

17

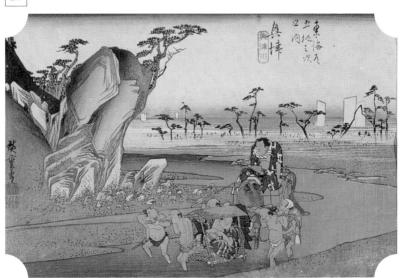

of a short hill near the entrance to a shrine. The road and the buildings looked nothing special at first glance, but there was something about the angle of incline and the presence of two *ryotei* (traditional Japanese restaurants), on the left-hand side that rang a bell. I took out my pocket-size Tuttle edition of Hiroshige's *Fifty-three Stages of the Tokaido* and checked stage number three, 'Kanagawa'. The print showed a road climbing steeply on the right and a row of inns with maids tugging at the sleeves of prospective clients; to the left, the sea with two prominent cliffs, and a lower hill in the distance. My view was blocked by the nearby buildings, so I climbed to the top of the steps leading to the shrine; from there I could see the two cliffs, and the hill in the distance I identified as the Yokohama Bluff. Only the sea had disappeared, buried under concrete and steel.

There has been an ironic shift in place names. When Hiroshige made his sketch of Kanagawa, Yokohama was a tiny fishing village of no importance, cut off from the strategic Tokaido by a wide inlet of the bay. Kanagawa was the important place, one of the fifty-three post-towns, or stages, established by the Tokugawa *bakufu* or military government. Today, Kanagawa has been subsumed into Yokohama, the second largest city in Japan. It survives as a

EJIRI Now part of the port of Shimizu, Hiroshige's scene combines the prosperity of the fishing village and the legend of 'Hagoromo' at Miho-no-Matsubara, the pine-lined spit of sand in the middle distance.

18

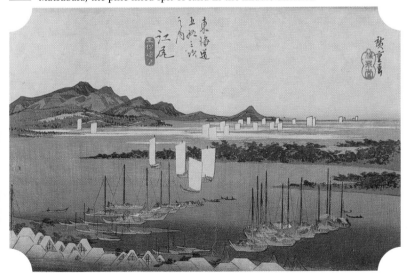

ku or ward and more importantly it has lent its name to the larger entity, Kanagawa Prefecture.

I set off up the hill and down the other side, passing several plaques depicting Edo era scenes set up by the local historical society. Then on past a collection of old *kura*, fire-resistant storehouses with whitewashed earthen walls, heavy doors and just one small, high window with thick earthen stepped shutters. They were set apart from the main dwelling. If the house was destroyed by fire at least the contents of the storehouse would be safe. Then past a quarter-size red *torii* gate leading to a miniature shrine. A schoolgirl in sailor-suit uniform sat on the curb, framed by the gate, head in hands, staring at the ground.

Just before the next stage, Hodogaya, the Old Tokaido goes through a narrow, bustling, shopping street, over Katabira bridge and (Hiroshige would weep, for this is where he once drew a rustic riverside) between the concrete supports of a station on an overhead railway line, with a row of automatic ticket machines on one side and the ticket barrier on the other.

You come out at a little garden where a rather confusing map shows two different routes of the Old Tokaido superimposed on a modern street plan. I followed the older

FUCHU This stage is now called Shizuoka, taking its name from Mount Shizuhata seen in the background. Hiroshige features three modes of transport of humans and three of cargo. Tokugawa Ieyasu built himself a castle here and near here the last of the Tokugawa shogun's came to live out his days in retirement.

19

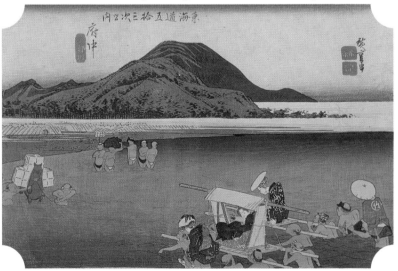

of the two routes which turned out to be a charming, narrow, winding path, leading past a shrine, a stone Jizo, (the Buddhist deity of suffering humanity in general and travellers in particular), and two temples. There are so many back roads here that I was not sure if I was really on the right one. While I was looking at the shrine a priest in white vestments and aquamarine *hakama*, loose-fitting trousers, approached down the stone pathway. He took me to the shrine office where he showed me an old ink drawing of the shrine and its surroundings and pointed out the different routes the Tokaido had taken over the centuries.

This section eventually goes over the JR Tokaido main line at a level-crossing and immediately joins the modern Tokaido, Route 1. On the opposite side is the site of the

MARIKO This tea-house, famous for its grated yam broth *tororo-jiru*, is mentioned by Basho and features in the comic novel *Hizakurige*. Hiroshige's figures are characters from the novel. Today's restaurant, specializing in *tororo-jiru*, is the direct successor of the establishment in the print.

20

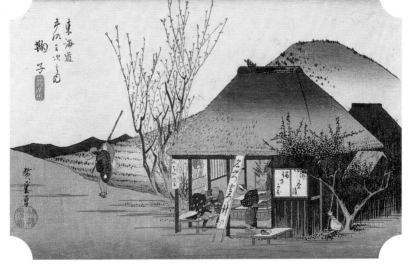

Hodogaya *honjin*. The *honjin* was the official inn established in each post town by the Edo government to accommodate *daimyo* on their frequent journeys to the shogun's capital. So far on my journey none of these structures seemed to have survived.

Traffic in both directions consisted mainly of nose-to-tail trucks. However, after ten minutes of hell I was back on a quiet stretch of old road, quiet except for a group of children in school uniform who plagued me with cries of 'This is a pen', the first, and in some cases the only, words of English learnt in school by Japanese children. To escape them I turned off the road through a gate to a temple where I found a deliciously secluded garden, with carefully landscaped trees, rocks, a waterfall and a pond

OKABE By squeezing the road into a narrow defile, Hiroshige cleverly remains reasonably true to the geography of Okabe town while conveying the loneliness and gloom of the feared, indeed haunted, pass deep in the forest higher up the mountain.

21

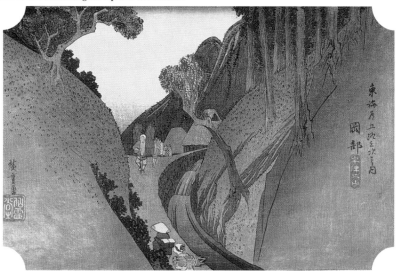

stocked with carp of every colour. This was the Japan I had always imagined, the Japan of the guide books, of refined aesthetics. Yet something was wrong and then I noticed the hum from the electric water pump that operated the waterfall and the array of photo-electric alarm devices guarding the fish.

Walking up the slope called Gontazaka I was curious to know what the girls I saw coming out of their high school learned in their history lessons. I asked if this was the Old Tokaido. Without hesitation they replied yes, and then explained where I would have to turn right a kilometre or so ahead.

The road here follows a ridge with views on both sides and for the first time since leaving Tokyo the scenery was semi-rural: vegetable plots, bamboo groves with little hidden Shinto shrines, and a pretty temple with a wood behind it where I found shade from the 32-degree heat and ate a mosquito-infested lunch. After Yokohama the road which until then had run due south turned west and somewhere along this stretch I had crossed the boundary between the ancient provinces of Musashi and Sagami. Except for the tarmac surface, an occasional car and a concrete incinerator tower on the next ridge, I felt I could

FUJIEDA Here we see the activities of a *tonya*. The tired horse in the foreground will be replaced by the fresh-looking horse to the rear. Workers load and unload, clerks handle accounts, all under the supervision of the official sitting in the raised tatami-matted area.

22

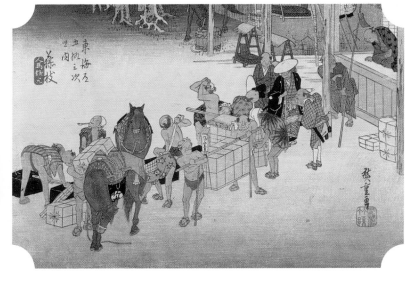

have walked back into the Edo period.

I was now well behind schedule. I still had to pass through three Tokaido stages, Totsuka, Fujisawa and Hiratsuka, before reaching Oiso where my friends were expecting me for dinner. I knew it was hopeless but I increased my pace until I was almost running.

Just after the rusty monorail track which passes overhead on concrete stilts on its way from Ofuna to the amusement park called Yokohama Dreamland was a love hotel. Two traffic lights marked the entrance: the red light had the word 'NO' on it; the green light, 'YES.' The 'YES' light was shining. One explanation one hears for the many love hotels in and around Japan's cities is that they are used by young married couples who have to live with their extended families in crowded apartments with paper-thin walls and

SHIMADA A daimyo waits while his entourage begin to ford the Oi River, the widest and most treacherous of the whole journey. The river has split into numerous channels and here it is only waist deep. Today a large paper mill stands on this bank.

23

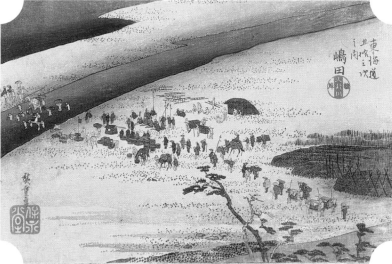

who are looking for a moment's privacy. It is not an explanation everyone accepts.

The road had become boring. I was now walking at a furious pace and I was aware that my feet were becoming a solid mass of blisters. When I crossed the bridge at Fujisawa, (a successor of the bridge in Hiroshige's print?) I was at a crossroads and it was dark. I asked at three shops for the route of the old road but was met with cocked heads, sucking of breath between teeth and a typically Japanese unwillingness to express a clear opinon. At the fourth shop I was directed up the hill, but after fifteen minutes I realized it felt wrong: too wide, too straight, no temples, no shrines, no Jizo, no pine trees, no *kura*, no buildings earlier than mid-Showa, no plaques, no monuments. I trudged all the way back, thirty precious minutes wasted; by the time I was back on the right road it was 7.00 pm. I was due at Oiso by nine at the latest: dinner, companionship, a bath, a bed for the night, all were waiting. It was hopeless. I was now crippled both by the blisters and the old injury to my knee. I could barely walk and my morale had plummeted. Was I going to cheat on only the second day? Hilaire Belloc had vowed to walk all the way on his pilgrimage from London to Rome, but he had ended up using transport. Besides, I really had

KANAYA One samurai remains seated on a litter while lower-ranking samurai, carried piggy-back, are deposited once the shore is reached. Over twenty bearers are needed for the high-ranking daimyo's palanquin, bottom left. Kanaya nestles in the foothills, top right.

24

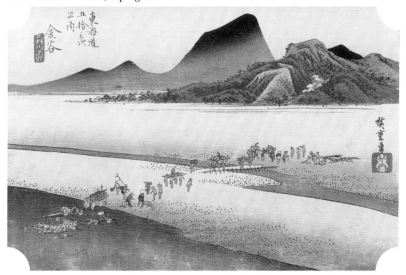

no choice. With great reluctance and overwhelmed by gloom, I hobbled to the station, and took the train to Oiso.

My friends met me at the station. After a bath and dinner, Shige, a pharmacist, provided Band-Aids and suitable ointment for my feet, but when he saw the state they were in, he shook his head and urged me to give up.

Back in my room I began to cull my rucksack to see if I could make it lighter without having to give up anything essential: out went the water flask (I had never been more than five hundred metres from a soft drinks machine), the miniature tape-recorder (an intrusive instrument), my electric shaver (batteries are heavy), a guide book (the Tokaido has been bypassed by the world of tourism). But it was all pointless; the few infinitely careful steps to my bed were agony. If I could not walk across a small Japanese-style tatami room, how could I walk to Kyoto? I would make the attempt another time, perhaps next spring, but for now I was going to have to tell everyone that I had given up after just two days. I felt very foolish. I fell asleep exhausted, heavy with feelings of disappointment and failure.

The next morning I got up late, ate the breakfast my friends had left for me, put on an extra layer of plasters, and set off slowly, very slowly, for the station walking on the

NISSAKA Travellers inspect a stone that can be heard wailing at night. It is haunted by the spirit of a pregnant woman murdered at this spot. Note the dramatic sweep of the road from extreme top right of the frame to bottom left.

25

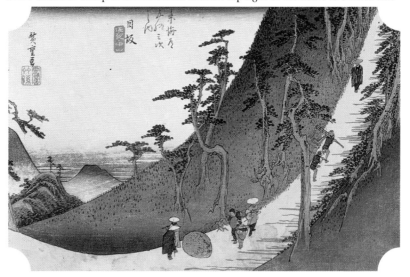

edges of my feet. My knee was swollen and I wondered if I had done it permanent damage. As I progressed down the hill, insistent voices in my head were whispering 'Never give in,' 'Get to Kyoto if it kills you'. Other voices said 'Be sensible,' 'Be realistic,' 'There'll be another time'.

I reached a junction: to the left lay the station and my home in Yokohama; to the right, the Old Tokaido and Kyoto.

I paused for a moment and turned right.

KAKEGAWA Once again Hiroshige cannot stay within his frame: this time it is a high-flying kite that just breaks through the top edge. Another kite, belonging to the child, is carried away by the wind towards Mount Akiba. Kites and rice-planting tell us that this is May.

26

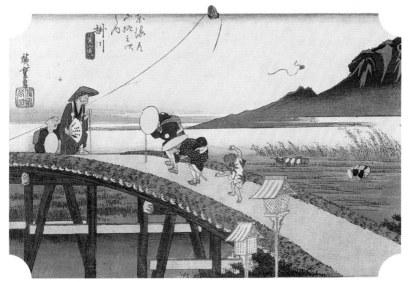

3

Hot spring haven

Oiso • Odawara • Hakone

I HAD MADE the fatal decision to continue walking, but it was 1.00 pm by the time I was even moving in the right direction. I dropped in at a shop to buy a sandwich for lunch and to ask the way. Two hundred metres later, I realized I had left my hat behind, essential protection against a relentless sun. I

FUKUROI Just outside the town limits marked by the tall *bohana* pole, two palanquin bearers and a messenger take a rest at a temporary roadside tea-house. Today, that same stretch of road is tarmacted but there is no traffic of any kind in sight.

27

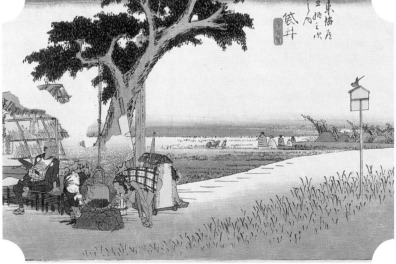

hobbled to the shop and then back again. Today's target was Hakone Yumoto. I had booked a room in a cheapish *ryokan* or Japanese-style inn and I was expected at around 7.00 pm. The distance was eighteen kilometres, a reasonable walking distance in normal circumstances, but I was late starting, it was extremely hot, and with my swollen knee and blisters, I was moving at a snail's pace.

Doubts about the validity of the 'walk,' with ten kilometres covered by rail and one of the fifty-three stages left out completely, nagged at me. What else had I missed? A lot of boring Route 1, certainly; but also Hiroshige's Hiratsuka, with its extraordinary bulbous mountain protruding above the pine-bordered road, a single well-rounded bosom, half-concealing Mount Fuji. What was it now? Weathered beyond recognition? Terraced to make room for the bleak concrete apartment blocks the Japanese call 'mansions?' I made a vow that if I did manage to get to Kyoto, I would go back and walk the missing link between Fujisawa and Oiso.

Conscience salved, I tried to quicken my pace, but the pain got worse and I stopped to investigate what looked like a small museum, the Denryu-an, which turned out to be a centre for writing the traditional poetic forms *tanka* and

MITSUKE A sand bar divides this major and sometimes raging river into two channels: in the foreground the Little Tenryu, to the rear the Big Tenryu. Beyond the Tenryu river but before Hamamatsu lies the half-way point between Edo and Kyoto.

28

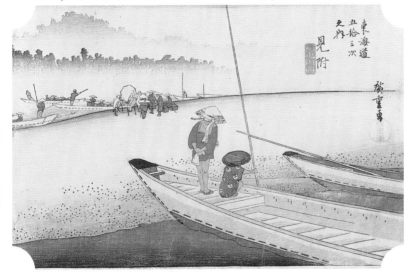

haiku, short, highly concentrated verse with thirty-one and seventeen syllables respectively.

My map told me to look out for the summer house of Ito Hirobumi, but I must have walked past it without noticing. Ito Hirobumi (1841-1909) was the father of the Meiji Constitution and Japan's first Prime Minister; it is because of him that Oiso became famous both as a centre of Meiji era politics at the end of the nineteenth century and as Japan's first sea-bathing resort.

Another distinguished Prime Minister, Yoshida Shigeru, who represented Japan at the San Francisco Peace Conference in 1951 and who oversaw the end of the postwar US occupation, lived further along on the same side. In those days, their summer-houses backed onto the sea, but today the approach to the litter-strewn beach is cut off by an expressway. Unlike some of his successors, Yoshida was greatly admired, and if you meet someone called Shigeru today, the chances are he was born around 1950.

I missed the postwar PM's house, perhaps because I was excited to find another Old Tokaido backwater. These 'ox-bow lakes' are havens of peace and quiet. The vehicle count

HAMAMATSU Warming their hands, and one his bottom, four *kago* bearers group around a fire they have made. A traveller, pipe in hand, hesitates to join them. The rising plume of smoke and the strong vertical of the tree divide the print neatly in two. Perhaps this is Hiroshige's way of suggesting that this is the exact halfway point between Edo and Kyoto, with the road, hidden by the grassy bank, curving away to right and to left.

29

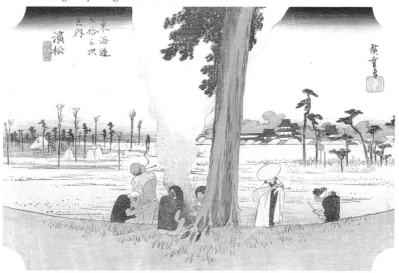

dropped from twenty-two per minute to zero, and for twenty minutes I was practically alone. At the point where I rejoined the main road, there was a metal structure with a bell at the top, a fire-warning watchtower, under which was a group of small stone Jizo statues.

The stretches of main road are not totally without interest. I later passed a handsome *kura* and an *ichirizuka*, the Tokaido equivalent of a milestone, literally a 'one *ri* mound'. The mound is quite large, about five foot high and has a tree growing out of it. In the Edo period, there was an *ichirizuka* for each of the 124 *ri* from Edo to Kyoto.

After Ninomiya ('twin shrines'), I saw the sea from the road for the first time, though the sound of the waves was drowned out by the noise of the intervening expressway.

Whenever I stopped to look at something interesting, I forgot about the pain in my feet, but when I started walking again, the pain became worse. I had been walking gingerly, trying to avoid direct contact between the ground and the biggest blisters, but it was getting dark and I was far from home.

I started walking fast and instead of hobbling on their edges planted the soles of my feet flat, deliberately aiming for the blisters, and as the nuns had taught us to do at

MAISAKA Hiroshige subtitles this print 'a true view of Imagiri'. He is being ironic because Imagiri (so called because a sandbank between Lake Hamana and the sea was cut as the result of an earthquake) looks nothing like this. Today the two sides are joined once more, this time by a graceful bridge carrying the expressway.

30

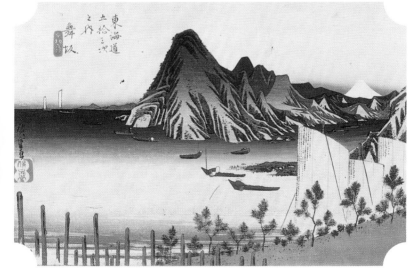

school, I offered up the pain, in this case, for a group of people at that very moment being held hostage. This in fact worked, because I got lost in contemplation of how infinitely worse it would be to be locked up somewhere in a small dark dungeon-like room. Then came the pleasures of masochism. My feet became suffused with a glowing, throbbing ache which reminded me of the bittersweet sensation five minutes after being caned at boarding school.

It was now too dark to see anything. I was sure I was missing interesting features and there was now little point in walking for the sake of walking.

Paul Theroux wrote somewhere that he never heard the sound of a train without wishing he were on it. That is not

ARAI A daimyo's ship crosses the lake, with pennants flying in the wind. This is the border between two daimyo provinces. Just beyond the landing-stage, upper right, there is a barrier, as at Hakone, where travellers are thoroughly searched for contraband and have their travel documents checked.

A commemorative lantern marks the site of the landing-stage, now well inland.

31

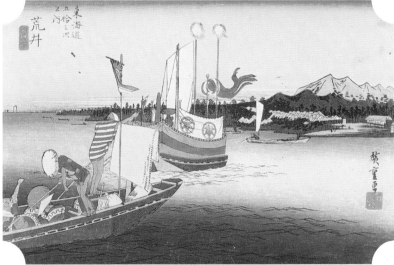

a feeling I share, with the exception of the little two-car Tozan Tetsudo railroad which starts at Odawara and whose standard gauge shares the narrow gauge with the Odakyu line's Romance Car, so that there are three rails instead of two as far as Hakone Yumoto.

I decided to take it. Directions to the station were given in excellent English by a young man who told me that he was a student of acupuncture.

'Don't go to Hakone,' he said. 'You can stay at my house.'

I thanked him for the offer, but explained that I had a room booked and that I was behind schedule and that it was a pity, because I could use his services for my knee injury.

'Then you must stay and I'll cure your knee without fail.'

But I took the Tozan train, got off at Yumoto, and climbed the steep steps to the *ryokan*. I had wanted a bath

SHIRASUKA Walking hats: a daimyo procession files down Shiomi slope towards Shirasuka stage and Edo.

An expressway runs on concrete supports midway between Hiroshige's shore and the horizon.

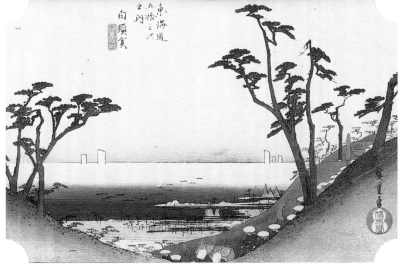

first, but I was already late and when I flopped onto the tatami matting in the restaurant for a *teppanyaki* dinner I was the last person to be served.

Waiting for the *teppan* plate on the low table in front of me to heat, I became filled with depression. I had now cheated twice, I had missed whole stages, I had grossly overestimated the distance I could cover each day, and at my present rate of progress and in my physical condition I had little hope of ever reaching Kyoto. Tomorrow I had to face the steepest climb of the whole journey: the ascent to Hakone Pass. I doubted whether my knee would hold out. Once again it all seemed very pointless.

But as the *teppan* warmed, and the pork and chicken and onions and peppers sizzled, and a beer or two later, my mood changed. Later, before going to bed, I sat in the hot-spring bath, beneath the stars, on a submerged throne of rock, a hot waterfall tumbling onto my head, all pain and despair forgotten. In such bliss, nothing seemed impossible.

FUTAGAWA The bleakest of Hiroshige's landscapes: the two bright spots are
33 the strolling minstrels and the local speciality tea-house that sells *kashiwa mochi*,
a sweet dumpling wrapped in an oak leaf.

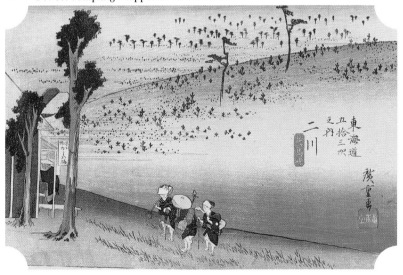

4

Stone pavement

Hakone

JAPANESE hot-springs come in two main varieties – open-air and enclosed. The open-air kind is called a *rotenburo,* literally 'bath open to the heavens', or sometimes it appears as *notenburo* 'field-sky bath'. Lying full-length in hot sulphurous water, gazing upwards into the infinite, is a great way to start the day. It had not been a good night. My room was on a cliff directly above the station forecourt and three drunks had carried on a loud discussion from midnight till 1.00 am. Once again, it was a late start as I trudged down the hill past the station to pick up the Old Hakone Road at Sanmai Bridge. From there it is a long steady climb for eight kilometres, not counting the bends, a vertical climb of 849 metres from sea-level at Odawara to the top of Hakone Pass.

This is a part of Hakone that most visitors never see: the

YOSHIDA A workman leans from the top of the scaffolding, his gesture mimicking the raised tail of the dolphin figure on top of the castle. His viewpoint reduces to insignificance the dark shapes crossing the 250-foot bridge spanning the Toyo river. Today's concrete bridge crosses fifty yards upstream towards the castle.

34

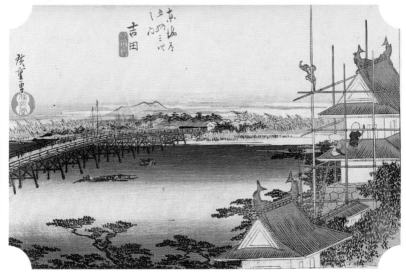

road hugs the mountainside and passes temples (one, Sounji, was where the sixteenth-century warlord Hideyoshi had made his headquarters before laying siege to Odawara Castle), shrines and the more discreet *ryokan* and hotels; the raucous and drunken commercial centre of this escape-from-Tokyo hot-spring resort with its tourist buses and *omiyage* (souvenir) stalls is on the other side of the valley. I wished I had been able to afford to spend the night here, in one of the expensive but tranquil inns.

Just outside the town, there is a large wooden board on the left-hand side marking the start of a hiking route. This links up with two sections of *ishidatami*, or stone pavement. Hiking routes are usually pretty tame affairs, but the previous night it had rained heavily and in several places the path was partially blocked by landslides, including one large

GOYU Evening arrivals at the inn. Goyu was famous for the aggressive tactics of its inn servants whose duty was to pull in the customers. Hiroshige very slightly exaggerates the style of those who sometimes took their job too literally. The name boards hanging at the entrance to the inn credit the craftsmen involved in the production of Hiroshige's prints. Today's picture shows a not dissimilar view minus the people.

35

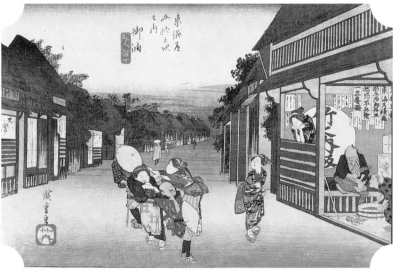

boulder that occupied the middle of the path. Having to cross the swollen streams on the crude and flimsy log-structures added to the air of drama.

The present stone pavement was laid during the dying years of Tokugawa rule to give a degree of permanence to a steep path whose surface was easily washed away by storms and the passage of countless feet. To begin with it feels exciting and romantic: this is the real Old Tokaido; but it is uncomfortable and slippery to walk on, and in any case the original surface pre-dates this by two-and-a-half centuries, if not a thousand years. The sections of stone pavement interweave with the modern asphalted road; the sign-posting can be confusing and sometimes you have to walk downhill on asphalt before picking up the next uphill stone section. Just before the village of Hatajuku the paved way

AKASAKA This amazing palm tree dominates the foreground from top to bottom, yet behind it we see in panorama the details of inn life: from left to right, a man returns from having a bath, a reclining guest and another coming downstairs are served their dinner, serving maids make themselves up in preparation for the evening's entertainment and behind them a pile of futons hints at pleasures to come, and sleep. The same print appears in the window of a contemporary inn, possibly the successor of the one in the print.

36

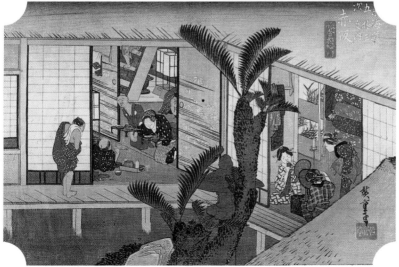

goes through a graveyard set in a forest glade.

Hatajuku is a half-way house between two stages: a good place to stop for lunch and then visit the waterfalls and rock pools in the charming garden that climbs up the steep hillside. A monument nearby states that the Emperor Meiji stopped here on his historic journey from Kyoto, the old capital, to Edo/Tokyo, the capital-to-be; and Townsend Harris, the first American consul, recorded in his diary his amazement upon coming across this garden when on his way from Shimoda for his long-awaited audience with the shogun.

Ordering food in a restaurant is made simple if one asks for the *teishoku*, a set menu, consisting of a main course, *miso* soup, rice and pickles, served on a tray. I had the *tororo* (mountain yam ground to a sticky paste) *teishoku* lunch at the Hata-no-Chaya, to the accompaniment of whistle-blowing and shouts as coach after tourist coach reversed into the adjacent parking lot.

'*Orai... orai...orai... sto!*' the parking attendants called. In other words 'All right, all right, all right, stop', a slightly corrupt formula picked up, apparently, during the American occupation. After lunch, more stone pavement, round the *nana magari* (seven curves) on the main road,

FUJIKAWA This is the procession in which Hiroshige himself travelled. The horses are the pair that will be presented to the Emperor and Hiroshige is said to feature in the print. Perhaps his is the face between the black box and the leading horse. Two animals join the group of citizens bowing to the procession as it passes the signs at the entrance to this stage.

37

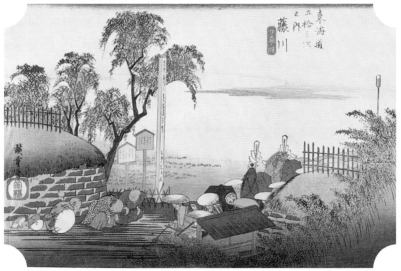

each bend with dented barriers and freshly broken headlight glass, free oolong tea at the historical Amazake *chaya* , a surviving Edo era tea-house, and a quick visit to the old tea-house museum next door.

Where the road peaked above Lake Ashi, I spent a fruitless half-hour trying to locate Hiroshige's view-point for his famous 'Hakone' print, but Mount Fuji was not visible to provide an orientation point, the nearby mountains looked less dramatic, the waterfall had gone and the hill-side was dotted with weekend homes. Anyway, I attempted a sketch and where I thought Fuji should have been I pencilled in the large electricity pylon that would probably have blocked the view of the great volcano.

I set off again and immediately saw a young couple, North American by their accents, approaching. The few Japanese I had passed earlier in the day on this path had all greeted me with a *'Konnichi wa,* (hello)'. These two passed me without a word and studiously avoiding eye contact.

The road wound down towards the lake and without warning I was back into the world of tourist Japan with its inevitable *omiyage* souvenir shops and stalls and where, gratefully, I chanced upon the *ryokan/minshuku* reservation centre. They found me a room in a *minshuku*, I paid a ten per cent advance and a 100 yen booking fee, and walked up

OKAZAKI A daimyo's procession crosses the Yahagi bridge, the longest on the Tokaido (1240 feet/378m): the bridge is so long in fact that that it runs off both ends of the print.

38

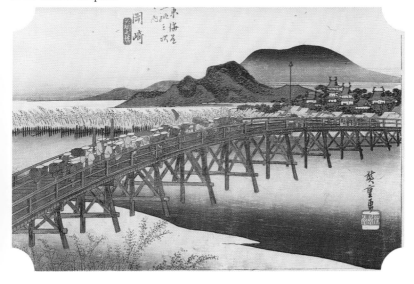

the hill to Ijima So Minshuku. A *minshuku* is the Japanese equivalent of a 'bed and breakfast' except that it always includes dinner as well. I had a bath and then a dinner of pork and ginger, grilled fish and *sashimi*, in my tatami room, with views on two sides of the surrounding hills.

'Come down if you want more beer.'

The owner was chatty and motherly, but unfortunately apart from this I understood very little of what she said. I fell asleep feeling contented: my knee had survived the longest and stiffest climb on the whole Tokaido; tomorrow I would pass unhindered through the once dreaded checkpoint, climb to the summit of Hakone Pass, leave the Kanto ('East of the Barrier') behind, and enter the – for me – unknown province of Suruga.

CHIRIFU A windswept grassy field used for auctioning horses. Auctioneers and buyers wait under a pine tree. There are several candidates for the pine tree or its successor in today's Chiryu. The photograph shows one of them.

39

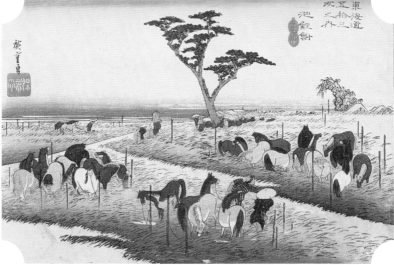

5

Incoming firearms, outgoing women

Hakone • Mishima

THE EARLY MORNING sun came streaming into my room at the *minshuku* matching my new-born feelings of optimism. Walking had become less painful and today I would be rewarded for yesterday's long climb. There was still a little way to go before reaching the summit of Hakone Pass, but from there it would be downhill all the way to Mishima and beyond. But most of all I was excited by a frontier sensation: Hakone checkpoint was not just a historic barrier. It also marked the limit of my previous travels west of Tokyo, (not counting trips to Kyoto by bullet train where one is effectively isolated from the intervening countryside). I stood at the border to an unknown land.

I left the *minshuku* early and returned to the stone paving of the Tokaido which soon brought me to the shores of Lake

NARUMI The print features well-dressed female travellers visiting this town famous for the tie-dyed *shibori* textiles that are displayed in the shops that line the road. Narumi and neighbouring Arimatsu have carefully preserved many of these buildings.

40

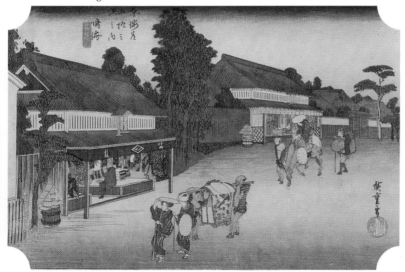

Ashi. A fake Spanish galleon surrounded by swan-shaped pedal-boats was unloading Sunday tourists at the lake's edge. A red, concrete, *torii* gate rose from the water. Lake Ashi is beautiful kitsch.

But then the road became a path lined by immense cedars, forming a wall of bark for the last hundred metres before the check-point. One of these cedars (more properly Cryptomeria japonica) is designated as the *tsumekaki*, the 'fingernail scratching tree'. Hakone *sekisho*, checkpoint, was the strictest of the Edo period barriers. Its main purpose was to stop *irideppo deonna*, incoming fire-arms and outgoing women, the women being daimyo wives held hostage in Edo by the shogun. Those who tried to escape in order to rejoin their husbands or who had lost their passports or who

MIYA A horse-driving festival is watched by travellers arriving at the post-town of Miya (meaning 'shrine'). The festivities are part of the life of the nearby Atsuta shrine, which houses the 'great grass-cutting sword' of the imperial regalia. The photo features the author standing by the shrine's massive *torii* gate.

41

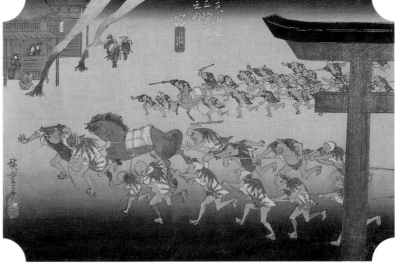

carried forged documents calmed their nerves by tearing at the cedar bark. Avoiding the checkpoint was punishable by death and the corpse was displayed at the barrier.

I reached the modern replica of the 1618 barrier. Tourists were everywhere. I took a quick detour through the museum, so as to pass scrutiny by the waxwork figures of shogunate checkpoint officials; but this was familiar territory from previous visits and I was hungry for something new. I left the crowds and followed the modern road along the lake-side. A smaller road led off to the right, and behind an untidy group of shabby houses I found a sign-posted path leading up the mountain. I set off uphill and for the next sixteen kilometres I was virtually alone in the world.

The modern road zigzags to the summit; the Old Tokaido goes straight up. Sometimes it passes under the main road in narrow tunnels; at others I had to negotiate the traffic to find the continuation. At one point the climb was a slippery 45 degrees and I had to haul myself up by grasping at the thick undergrowth. Near the top I looked back and the length of Lake Ashi lay far below, no longer kitsch but supremely beautiful.

The summit of Hakone Pass is 849 metres above sea level. It is the highest point on the Tokaido and marks the border

KUWANA A close-up view of two boats entering Kuwana harbour at the Kyoto end of the Seven Ri Ferry. This long sea journey (16 miles or seven *ri*) was considered safer than the alternative: crossing three broad, fast-flowing rivers.

42

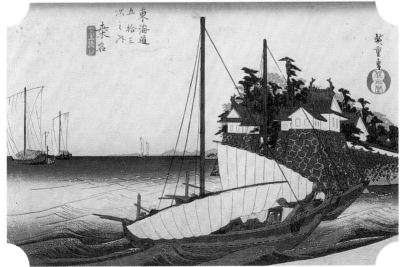

between Kanagawa and Shizuoka prefectures, or as I preferred to think of it, between the ancient provinces of Sagami and Suruga. It is also the western limit of the Kanto.

Four modern roads meet here and finding the continuation of what I now considered to be my own private path took ten minutes. When I got to it it was clearly sign-posted and marked as a hiking course. Few hikers could have used it because the bushes on both sides almost met in the middle. Later, after another main road crossing, the entrance to the next section could barely be distinguished from the surrounding vegetation. A notice stood in the middle of the path: *abunai*, dangerous, watch out. No one had been this way in weeks: I had to push away the creepers

YOKKAICHI The leaning figure, the flowing cloak, the bending marsh reeds and the hat about to roll off the corner of the print with its owner in hot pursuit: Hiroshige's humorous depiction of the effect of the wind. Today, this is a modern, prosperous petrochemical city but the contemporary bridge has retained some of the features of Hiroshige's.

43

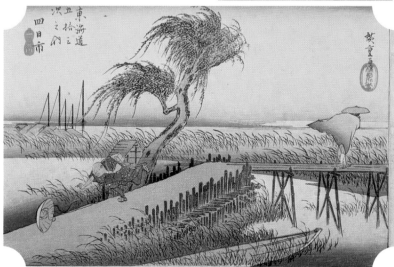

that dangled in my face and at one point I came within inches of a spider's web that straddled the path from one side to the other. The large yellow-and-black owner waited at its hub.

The road surface was grassy but it seemed strangely hard; and then I realized that I was once again walking on stone pavement, but now covered with grass, weeds and moss. The undergrowth grew thicker by the yard, till suddenly I pushed back a branch to find myself on the edge of a crater. The whole road surface had subsided leaving a hole twelve feet across, six feet deep. I picked my way round the edge and walked on, relieved that the reason for the *abunai* warning was behind me.

Further downhill the stone pavement became the bed for a clear running stream and I walked beside it. I passed an *ichirizuka* ('milestone'), a stone Buddha hidden in the undergrowth and, without warning, a human being, the first in three hours. He was from Mishima and was walking the Tokaido to Hakone. Neither of us expected the other and although I wanted to stop and talk longer we smiled awkwardly at each other and continued our separate ways.

All good things come to an end and I knew I was back on the main road when I counted a fleet of twenty-nine

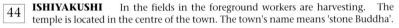

44 **ISHIYAKUSHI** In the fields in the foreground workers are harvesting. The temple is located in the centre of the town. The town's name means 'stone Buddha'.

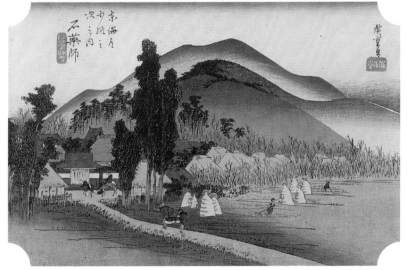

motorbikes. I thought at first that they were *bosozoku*, hot-rodders who ride in swarms of up to two hundred, gunning their mufferless engines in quiet neighbourhoods at 2.00 am, but these were ridden by proud and respectable owners of well-maintained machines.

The trail had ended near the ruins of Yamanaka castle, deep grassy moats surrounded by the grass-covered foundations of outer walls, inner fortifications and keep, the whole climbing the hillside in broad terraces. From the highest point I surveyed a magnificent panorama: the mountains of Izu sweeping down to Suruga Bay and to the west the steady decline of the Hakone mountains towards Mishima and Numazu. The weather was perfect, yet on this late summer Sunday afternoon there were just three other people visiting the ruins.

From the castle the old road ran parallel to the new and joined it at a messy-looking roadside cafe. Customers could help themselves to free oolong tea dispensed from a large shiny green plastic urn bearing in English the encouraging words: 'Enjoy active life with your well-equipped body'. At the edge of the cafe parking lot stood a large black, stone slab, inscribed with a haiku by Basho. Basho had made this

SHONO Along with the print of Kambara, this is often cited as the outstanding work in the series. The slope is for effect: to emphasize the discomfort of those struggling against the gradient. The road near Shono is essentially flat. The umbrella carries the characters for 'fifty-three' and Takenouchi, Hiroshige's publisher.

45

journey twice and from here he had expected to see Mount Fuji:

> *Kirishigure* Misty autumn rain
> *Fuji wo minu hi zo* Fuji is invisible
> *Omoshiroki* How fascinating!

In the Edo period, Mount Fuji was visible from Nihonbashi. It appears prominently in Hiroshige's 'Hakone' but because of clouds and pollution I still had not seen it on this journey.

The descent from the pass is long and gentle. I was walking on asphalt but there was no traffic, at most one car every five minutes. An old lady stood in the middle of the road muttering: 'I've lost seventy-six thousand yen.

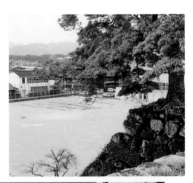

KAMEYAMA In the calm after the snow storm, a daimyo procession climbs the last stretch to the castle perched on the ridge. Kameyama lost its importance with the advent of railways when the main line from Tokyo followed a northern route that by-passed the whole prefecture. A contemporary picture shows the surviving castle walls which now form part of a public park.

46

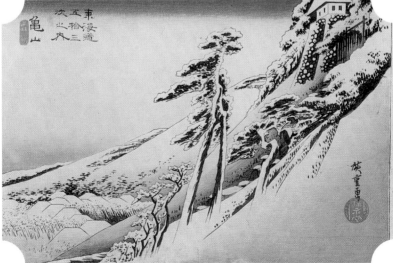

I put it somewhere but I can't remember where.'

A few minutes later Mount Fuji appeared through a break in the clouds but it was only a smaller Fuji look-alike. Seconds later the near-perfect cone of the real Fuji towered majestically over the surrounding hills and wide plain.

An hour later I was nearing the outskirts of Mishima. The old road ran parallel to the new. In places the dead hand of municipaldom had organized it and made it neat and tidy; at others it ran wild behind the back of houses and in tunnels of vegetation.

It was dusk as I walked down Mishima's broad main street with the entrance to its great shrine—a *torii* gate flanked by stone lanterns — looking much as it appears in Hiroshige's print. I called in at a drug store for Band-Aids and other supplies such as shampoo, but my main purpose was to ask where I could find a hotel. The shop, I was told by Mr Watanabe, the proprietor, was four hundred years old and had been in his family for eighteen generations. It had once been a toy shop and on a top shelf was one remaining stock item: a now antique doll. I paid for the bandages and was

SEKI The town's name means barrier or checkpoint. This is a *honjin* or main encampment, the inn where daimyo stayed. The inn displays bunting with family crests and the nameboards of distinguished visitors. Seki today is a well-preserved Edo-era post-town yet with a lived-in feel.

47

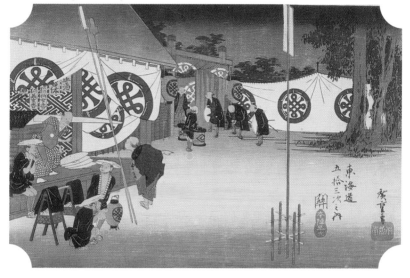

given a present of a handful of shampoo sachets.

The hotel he had recommended was modern, clean, comfortable and amazingly cheap, half the price of a similar hotel in Tokyo. Dinner was inexpensive and the cooking was good. Back in my room, in the bedside table I found a Gideon Bible and a volume on the teachings of the Buddha. I chose the latter and soon fell contentedly asleep with dreams of protective wayside *bosatsu* and clear streams running over mossy stone.

SAKANOSHITA The odd name of Mount Fudesute, which Hiroshige features in this print, derives from an incident in which the celebrated artist Kano Motonobu threw away (*sute*) his brushes (*fude*) when he could not capture the beauty of the mountain in a painting.

48

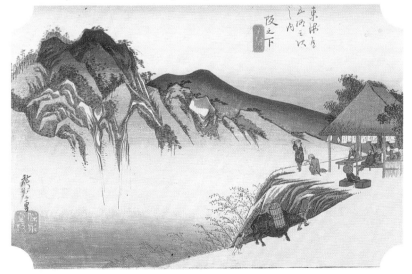

6

The road by the shore

Mishima • Numazu • Hara

GUIDE BOOKS give Mishima one line. It is a place you go to when you want to go somewhere else — such as Mount Fuji or Shuzenji hot spring. However, I had already decided to take a half day off to explore the town and I was looking forward to trying to find the exact spot where Hiroshige had stood to make his drawing of the bridge at Mishima, one in a less well-known series of Tokaido prints.

I left my backpack at the hotel and enjoyed a leisurely, burdenless stroll towards Mishima shrine. Mishima is a city of water; it comes gushing out of rocks and tumbles into pools in shaded gardens; it flows in carp-filled streams that run down the side of weeping willow-lined roads. Little bridges cross to the houses that stand on the other side. Steps lead down to the water and children play in it. It runs

TSUCHIYAMA A spring downpour overtakes a daimyo entourage crossing a bridge just outside the town. They have just completed the arduous ascent of Suzuka pass. The town's daimyo inn can still be seen today.

49

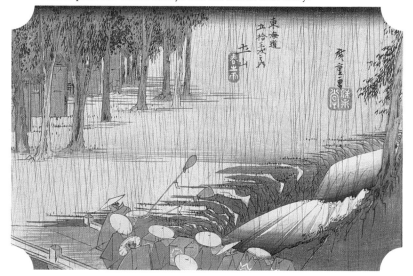

cool and crystal-clear. There are no factories between Mishima and the melting snows of Mount Fuji.

One of these streams flows through the spacious precincts of the great shrine. The shrine stands on the Tokaido at the junction with the road to Izu. This is the point where Townsend Harris, the first American diplomat to be accredited to Japan, had joined the road in 1857 on his journey by horse and palanquin from Shimoda to see the shogun. A very kind and friendly priest took me on a guided tour and related its history. Minamoto no Yoritomo the twelfth-century contenders in Japan's equivalent of the Wars of the Roses. Exiled in the remote Izu peninsula, he had prayed here for a Genji victory, and after the defeat of the Taira clan, as a result of which he became shogun, he

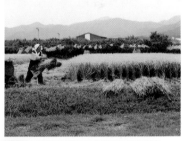

MINAKUCHI　　Hiroshige depicts the process of shaving and drying gourd peel. This is *kanpyo*, the delicacy for which the former castle town was famous. The scene today is thoroughly rural: against a backdrop of mountains the rice harvest in September is in full swing.

50

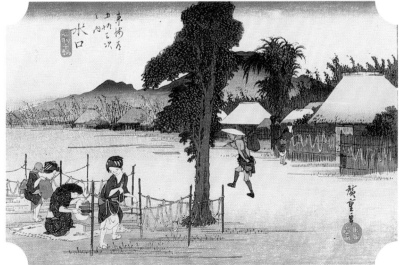

had returned as a benefactor.

I showed the priest the Hiroshige print of the bridge with Fuji in the background; he told me where I would find it. The modern bridge is concrete and flat, whereas Hiroshige's had been wooden and arched. As I expected, Mount Fuji was invisible. I took up a position on the left bank facing in the direction where I calculated it should be and made my own sketch. It did not look right. I was sketching from ground level; Hiroshige almost always chose a high vantage point. He had been a member of the shogun's fire-brigade and he would have known what a landscape looked like from the top of a fire-watch tower. I climbed the metal outdoor staircase to the second floor of an office building nearby and asked a surprised supervisor for permission to

ISHIBE As is so often the case Hiroshige is interested in contrasts: a group of light-hearted pilgrims practise the dance they will perform at the Ise Grand Shrines, while a smaller somewhat sad little group looks on; further down the road two porters are weighed down with heavy loads. The wall in the photograph looks as though it could be the very same wall as the one to the far left of Hiroshige's print, but equally it could have been built more recently with that echo in mind.

51

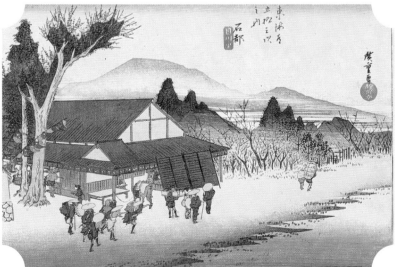

sketch from the landing. The result was no better than my first attempt but I felt I now had a better appreciation of the geometry of a Hiroshige landscape. Just as I was about to descend the stairs the clouds cleared momentarily and Mount Fuji (or was it only my imagination?) appeared in the distance in exactly the right place, slightly to the left of the bridge.

At 1.30 pm I was back at the spot where I had left the Tokaido. I called at the pharmacy to say goodbye and to thank Mr Watanabe for recommending such a good hotel. Once past the town centre the road was modern and wide but virtually empty. A young paraplegic in a wheelchair kept me company for a hundred yards. His speech was severely impaired but we communicated somehow and I kept up my side of the conversation by telling him about my journey.

By 3.00 pm I was starving and I started to look for somewhere to eat the take-away sushi I had bought earlier. I spotted a small road leading off at a slight angle; this often signalled a stretch of Old Tokaido left untouched when the road had been widened and straightened to carve out Route 1. It was a short loop but it contained a well-preserved

KUSATSU This post-town prospered because it stood at the junction of two main routes to Kyoto, the Tokaido and the Nakasendo. Hiroshige captures an atmosphere of considerable activity and a sense of urgency: note the strap-hanging passenger in the open *kago* holding tight to avoid being tipped out. Neither party has time to stop for the local delicacy provided by the tea-house.

52

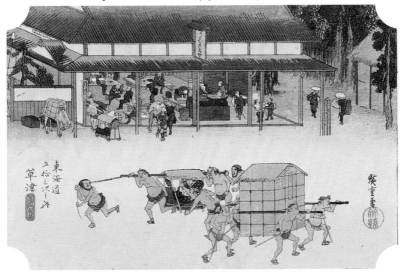

ichirizuka, (a large mound planted with a tree) and a shop from late Edo/early Meiji days. In Europe or the USA a building of the 1870s would be nothing special but in Japan it is a comparative rarity and the Old Tokaido has more than its fair share. I climbed to the top of the embankment at the edge of the road and discovered a wide and deep-blue river running between grassy banks. I flopped onto the grass and washed down the sushi with a can of beer, and watched as fish leapt out of the water, kingfishers swooped, and dragon-flies hovered and darted.

European cities have a well-defined centre, a cathedral, perhaps, or a square with a town hall. Numazu is like any other city centre in Japan, a main street full of banks and the usual shops and I am not surprised that it merits not a single

OTSU The last stage before Kyoto. This shop was famous for its rice cakes and for the purity of the water gushing from its well. Wheeled vehicles appear for the first time; elsewhere on the Tokaido they were forbidden. Today's high street follows the old road.

53

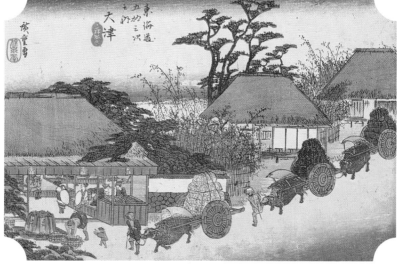

line in any of the guide books. My map indicated the existence of the Old Tokaido but I could not find it, and for ninety excruciating minutes I traipsed down a noisy, characterless road, breathing diesel fumes. I took my mind off the succession of filling stations, monster drive-in pachinko parlors and Nissan showrooms, by taking a traffic census: forty-four vehicles per minute as against just two or three at Mishima. Boredom was becoming a serious threat. Next, I tested the answer given to the Trivial Pursuit question: 'What is the most common colour for Japanese cars?' The boardgame-makers had got it right: white, by a long chalk.

Well outside Numazu, a small road joined from the left. It was the road I had been looking for. This was confirmed by a draughtsman working in an architect's office nearby. He directed me to an even older stretch of the Tokaido that ran by the sea-shore. This was narrow and winding and there were occasional scraggy wind-swept pines at its edge.

I stopped to peer into a muddy scrap-yard filled with oily cans, old sumps and piles of metal turnings, the whole place reeking of grease. A pick-up truck loaded with yet more turnings pulled off the Old Tokaido into the yard. Its driver, young, dark brown face, curly black hair, flashed a broad

KYOTO From one end of the bridge a daimyo's palanquin approaches; from the other elegant ladies of the emperor's capital set out. The crossing of the Great Sanjo Bridge marked the end of the 303 (488 k)-mile journey from Edo, that had taken on average 14 days. Today's bridge is built in a similar style, including the characteristic railing-post knobs, but the supports are concrete.

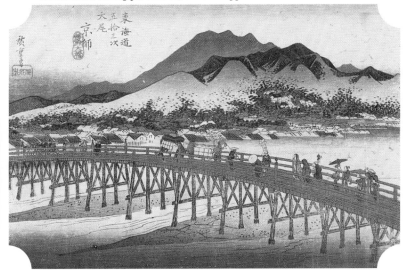

smile. He was from Bangladesh and we chatted a while in English.

'By the way,' I said, 'did you know that this was once the most important road in all Japan?'

'No,' he grinned, 'I can't say that I did.'

The road ran next to the sea but the sea and the sound of the waves were blocked out by a huge wall. The beach when I got to it was filthy and the sand was covered with rusty metal sheeting, though from the top of the wall there was a magnificent view of the pine-lined coast towards Izu, and, to the right of the road, Mount Fuji glowing in the setting sun.

For the last hour before Hara I walked in the fading light through a pine forest. A lone figure walked ahead of me and I caught up with a retired bank official who told me his life story. He also explained the metal sheeting: this beach was where the Self-Defence Force tanks, based near the foot of Mount Fuji, practised their invasion manoeuvers.

Hara is little more than a village strung out along the Tokaido, with a small railway station. I found an inexpensive-looking *ryokan* but there was no sign of either host or guests. Eventually, the owner answered my calls. She told me the inn was full. I looked around the wide *genkan*, where outdoor wear is exchanged for slippers: no sign of any guests' shoes. I suspected discrimination. Outside I took down the telephone number from the signboard, vaguely planning to find some way of checking whether it really was full. I could call Tokyo and get a Japanese friend to try to reserve a room. As I was writing the owner happened to come out and, as if reading my mind, apologized again for having no vacancies.

In the Edo period, Hara was a busy post-town and I could have chosen from thirty or forty inns. Today, the only other place I could find was a gloomy-looking love hotel, consisting of a series of outhouses, on a desolate stretch of Route 1. I seemed to be the only customer. A dog howled in the night as the manager took me down a dark and narrow alley between two rows of huts. I had already made up my mind that I would stay anywhere rather than here when he opened a door to reveal a double futon on the floor of a very pleasant and inviting tatami room.

'Six thousand yen after 10.00 pm,' he said.

It was now 8.00 pm I said I would be back and set off to find

somewhere to eat in the meantime. A little further on I passed a woman standing outside what looked like a clinic. I asked if she knew of a nearby hotel.

'Why don't you stay here?' she said. 'This is the Radon Centre. It's a hot spring health centre but they have rooms as well.'

They found me a room and told me that if I wanted to use the bath I would have to hurry before it closed. In the spacious bathroom, fiercely hot greenish water poured in immense quantities from a mouth-like aperture in the marble walls into a Roman-style bath. I soaked away the day's aches, amazed at my good fortune. I cupped a little of the water from its source and swallowed it and just as soon saw the notice: `Warning. Do not drink.' Radioactivity... radon gas... disquieting concepts ran through my mind as I towelled myself off in the locker-room.

The only other client was a middle-aged man, quietly exuding an air of contentment and success.

'Let me guess. You're a doctor, aren't you?'

'Not bad,' he replied. 'I'm a dentist.'

Dinner was curry rice in the cheap and cheerful transport cafe next door. I was given a warm and noisy reception – '*Irasshaimase*, welcome!' was shouted out by the two cooks and the waitress – and when later I explained what I was doing, the cook from behind the counter asked me in a matter-of-fact way if I knew Hiroshige's 'Hidari Fuji'. *Hidari* means left.

'It's three or four kilometres further on, and it's the only place on the Tokaido where you'll see Mount Fuji on the left-hand side of the road.'

I had seen a 1920s' sepia photograph of this scene and it looked almost exactly as it does in the Hiroshige print. I could not wait to see what it looked like today and on which side of the road, if any, Mount Fuji would appear.

7

Fuji on the left

Hara • Yoshiwara • Kanbara

HARA is the closest the Tokaido gets to Mount Fuji. Hiroshige conveys its height at this point by allowing the summit to soar above the standard woodblock print border. I set out along the road on another hot, early September morning. The road ran straight. The sea, soundless and invisible, lay five hundred yards to the left; the main railway line passed close by to the right. The dark blue carriages of a night train from the southernmost island of Kyushu rumbled by towards Tokyo. Beyond the tracks fields rose away from me, at first imperceptibly, then more rapidly to disappear into the haze that hid the volcano.

Somewhere in the middle ground was a famous marsh — perhaps now drained — which had been the inspiration for a celebrated *waka* poem from the eighth-century *Man'yoshu*, 'Ten Thousand Leaves', collection and which all Japanese are almost able to quote from memory. It speaks of the view from Tagonoura and the pure snow falling at the summit of Mount Fuji:

Tagonouraya	*Tagonoura*
Uchi idete mireba	*Stepping outside I look*
Mashiro ni zo	*Oh purest white!*
Fuji no takane ni	*High on Mount Fuji*
Yuki wa furikeru	*The snow is falling*

Old illustrated maps of the Tokaido show temples and shrines standing guard at the top of myriad flights of steps. Bishamon-do, at old Yoshiwara, is reached by a triple flight. As my eye at last came level with the top-most step, a vast precinct opened up, shimmering in a pool of heat haze. I visited the shrine buildings not so much for their own sake as to escape from the heat and the blinding glare that came off the expanse of white gravel.

On my way back I found a little girl standing all by herself in the middle of the forecourt. She told me that her name was Emi

and that she was five years old. She chatted away oblivious of my incomprehension, keeping to my side all the way across the precinct, down the three flights of steps, and then for a hundred yards along the road towards Yoshiwara. Was she going to chat like this all the way to Kyoto? Would I be arrested for abduction? I felt responsible for a stray and looked around for someone to entrust her to, but then with a 'bai-bai' (the Japanese pronunciation of the equivalent English phrase, now standard among young Japanese when saying goodbye) she turned off into one of a small group of houses.

The road ran through fields; there was almost no traffic and no one else walking, in fact no one at all. And then suddenly a smile of recognition from an old lady standing on the grass verge with a stainless steel canister on her back, head wrapped up in the bee-keeper style common amongst Japanese golf caddies. She was spraying the grass verge with weed-killer.

'I saw you last night at the Radon Centre. I go there for my arthritis.' She was perhaps seventy years old, once beautiful... no, still beautiful.

At a level-crossing I had to wait ten minutes while a diesel locomotive went back and forth across the road, shunting wagons down the line. I used the time to study an old and handsome wall of red brick behind which stood a dilapidated store-house decorated with the criss-cross black and white pargeting typical of the merchant town of Kurashiki, in western Honshu.

Yoshiwara, an important enough place in its day, has no place in a bullet-train world. It has been swallowed up by Fuji City. This city has one *raison d'être*: the manufacture of paper. Paper mills need water and the five big mills take in the pure local *waki mizu*, spring water, and spew out a sickly green sludge that filled every watercourse I crossed.

My Old Tokaido map showed the road turning sharp right and then following a long leftward curve as if skirting a wide but invisible pond. Today I could have taken a short-cut straight across and saved a couple of kilometres. The marsh this deviation was created to avoid had long since been drained. But then I would miss 'Hidari Fuji' and it was precisely this long way round that would put Mount Fuji, just this once, on the left-hand side of the road. However, at the complicated crossroads where the Shinkansen zips by overhead, I was too clever by half: I chose the

wrong road and was soon hopelessly lost. A narrow lane between two factories would take me back to my starting point. It came to a dead-end with a ditchful of sludge on one side and a blank wall on the other.

I pulled myself up and over the wall. I was on factory property. I tried to look innocent as I sauntered past the uniformed guard at the gate.

'Hey! Where did you just come from?'

I pointed vaguely behind me and speeded up past his incredulous gaze.

The road looked promising. I took out my pocket Tuttle *Fifty-three Stages of the Tokaido* to check the radius of curve that would lead first right then left, with Fuji over there in the top left-hand corner. The contour of the road ahead of me was too good to be true but there right beside me was a bus stop and the name of the stop was clearly written: 'Hidari Fuji' (Fuji on the left). And Mount Fuji? Perhaps behind that factory or on the other side of that mansion block. *Wabi sabi*, the aesthetics of the unseen, beauty in imperfection. Hiroshige would perhaps be disappointed but I suspect the poet Basho would have appreciated the irony.

I had a lunch of *onigiri*, rice balls, and beer, sitting sweltering at the foot of a monument commemorating, if I had identified it rightly, a twelfth-century bloodless victory of the Genji clan over the rival Heike at the Fuji River. Afterwards I ambled slowly through the tacky suburbs until, disconcertingly, the old road passed down a stylish, modern shopping street arcaded on both sides. The shops were cool and expensive: Louis Vuitton, Chanel, Giorgio Armani, Gianni Versace. I walked under the shade of the arcade to the sounds of Pachelbel's *Canon* from the street's public address system.

Evening came and it was time to start thinking about where to stay for the night. Kanbara, if it had a hotel, was too far ahead. A night in Fuji City meant retracing my steps and sleeping amongst the smoke-stacks.

At the end of the bridge across the Fuji River there was a barber's shop. I pushed the door open and stood in a room surrounded by photographs of Mount Fuji: Fuji in springtime, Fuji topped with flying-saucer-shaped clouds, Fuji framed by autumn-tinted leaves, Fuji with the first snows. The barber told me that the only reasonable hotel was in Fuji City. I was driven to it by his wife, in

their large and luxurious car, my vague protests having been swept aside. I sank back into the plush seat and enjoyed the soft music from the car stereo.

After checking in and taking a shower, I wandered off into the deserted town centre to find something to eat. I found a sushi shop, sat down at a low tatami table and gave my order. I was the only customer. All around the shop were very beautiful close-up photographs of flowers.

'It makes a change,' said the owner. 'Everyone else in this city photographs Mount Fuji.'

The hotel was functional and my room smelled vaguely of mildew. That night I was awakened by three *bosozoku* (literally 'speed tribe',) bikers who shattered the peace by gunning their silencer-less engines around the block for twenty minutes. When the racket finally faded in the distance I calmed myself by walking the next day's journey in my mind: Kanbara, blanketed in snow in one of Hiroshige's most famous prints; Yui, where travellers had the choice of risking drowning in the ocean or being attacked by bandits on Satta Pass; and Okitsu, tomorrow's goal, known to all lovers of Oliver Statler's *Japanese Inn*. But as memories of that book's lyrical opening paragraph ran through my mind so did a premonition of disappointment.

8

Satta Pass

Kanbara • Yui • Okitsu

ONE OF the pleasures of travel is the freedom to do things you would not do at home. I have always felt a strong social pressure against wading through the Tama River on my way to work in Tokyo. Here on the banks of the Fuji River, halfway between the post-towns of Yoshiwara and Kanbara, I was free to choose. I had already walked across the bridge the previous evening. Now was the time to indulge a fantasy.

The river was perhaps two hundred yards wide from bank to bank, but the level was low. Travellers on the Old Tokaido forded it at this point, admittedly with the help, and on the shoulders, of guides. But authenticity beckoned. I made my way down the concrete embankment, picked a route over rocks and minor side streams and clambered over four or five concrete blocks.

A three-foot gap in the rocks channelled a stronger current but this was easily bridged. I had two prospective routes to the other side. One was through a wide, calm, but possibly deep central channel; the other would require edging across the top of a weir where the flow would be rapid but shallow. I reached the weir. I was now perhaps one-third of the way across the river, my shoes still not wet. It was at this point that I realized where this particular fantasy had come from: Harry Lime in *The Third Man*, pursued through the sewers of Vienna.

The sound of the cascading water, a mere murmur at the river's side, was here a deafening roar. I decided that it was better to arrive than to travel hopefully. I retreated and made a conventional crossing via the bridge. I called on the barber to thank him again for last night's lift and for lending me a selection of his best photos of Mount Fuji. I also wanted to know where I would find the continuation of the old road. He pointed to a side road upstream. I would have gone downstream. But I managed to take the wrong turn and heard a voice calling: 'Not

that one, the next one.'

This quiet, narrow road wound up the hillside and provided a magnificent view of the Fuji River. At the top it went past the long frontage of a samurai residence with its high, eaved wall and roofed gateway. The roads here all looked old and I took several wrong turns. I came to another junction where one way ran downhill, the other ran level. I asked an old lady which I should take. Either one was good, she said, but the upper road was the original.

Her directions took me towards a dead-end at a long concrete wall. Weeds protruded through the asphalt and the road petered out into a short flight of steps down to a narrow tunnel underneath a railway line. And then there was a swoosh, a blur of blue and white, the crackle of sparks, a sudden change in air pressure. In the concrete of the tunnel someone had inscribed '1964', the year when the bullet train made its debut and Japan's newest route sliced through its oldest.

Both the Shinkansen and the Tomei Expressway played havoc with the Old Tokaido's geography. The road went straight ahead but a bridge offered another path to the left over the expressway.

'You look lost. Can I help you?'

This in excellent English from a young man in a T-shirt and track-suit. Mr Ohira had spent two years in Kingston, Ontario, with Alcan, and was now working for Nippon Light Metals at their Kanbara aluminium plant. This was his lunch-break. He walked with me down to Kanbara.

'Extracting aluminium uses a lot of electricity, doesn't it?' I asked.

'Yes, but we generate our own.'

He pointed to four large pipes that brought the water straight down the mountainside, under the old road, to the company's turbines.

Kanbara *shukuba*, the post-town proper, is set back one block from the modern road. Entering it and leaving it by the old road and walking down its quiet main street with its mixture of Edo and Meiji wooden buildings I was very nearly able to ignore the existence of the twentieth century.

Does it snow in Kanbara? I doubted it and on this scorching day with sweat pouring down my face and my shirt dripping wet against my backpack, I felt no inclination to try to identify the

site of Hiroshige's famous wintry landscape. Besides, I wanted to get to Yui.

Yui stood at the foot of Satta Pass. Its name evoked potential drama. (It was also the name of one of my students. She told me it was easy to remember because you could find it on the top row of a typewriter keyboard.)

When I reached the Yui River I found four bridges side by side: the new Tokaido, the old Tokaido, the railway, and the expressway. Between the mountains and the shore there was little room for even one of these and the expressway, coming last, was forced to stand with its concrete legs in the sea.

Ugly though it was, the expressway would provide shade and the inevitable concrete tetrapod wave breakers a place to sit for a picnic lunch. I left the road and followed a path down to the sea and in so doing discovered the spot where the old road had forded the river. It was marked by a stone Jizo and a small shrine encased in a faded red wooden box.

I found a tetrapod as far out into the sea as possible and laid my picnic precariously on its 'feet'. Every third wave threatened to sweep away my can of beer. The traffic passed overhead but its noise was drowned by the crash of the waves resounding in this concrete cavern.

On the horizon, jutting out into the ocean, I could see clearly the steep slopes of Satta Mountain. Where it plunged into the sea there was no room for a road. This was where travellers had had to wait for low tide and still risk drowning. Locals had dubbed the promontory '*Oya shirazu, ko shirazu*': parent forgets child, child forgets parent.

Later in the Edo era a new road was built over the top and it was this road I was to take after walking the length of Yui's ancient and narrow main street. It is a long, steep climb to the top of Satta Pass. The road has been overlaid with ribbed concrete to make it easier for the farm vehicles to reach the *mikan*, satsuma orange, groves that cling to the mountainside. Below me lay a hazy but fabulous seascape, the broad sweep of Suruga Bay from Satta Point to the Mountains of Izu, the ocean a deep blue in between.

'Would you like a tomato?'

She was wearing farm clothes and had a large basket strapped to her back. She had appeared suddenly while I was taking in the view.

'I've only just picked it.'

I accepted the offer. It was warm, deep red and juicy.

'I'm eighty-one. Five years ago I travelled all around Europe. I have very happy memories of that trip.'

Even in Edo days Satta Pass was famed for being lonely and plagued by bandits and today we were the only people in sight.

From the top of the pass the road descended through a dark forest of firs. It would have been romantic without the rubbish that littered the ditches on both sides. By the time I reached Okitsu, night had fallen and I asked a policeman where I could stay.

'There's a small hotel but it's fully booked.'

What about the Minaguchiya (of *Japanese Inn* fame)?

'Oh, that closed down five years ago. You'll find somewhere to stay in the next town.'

I took the train to Shimizu, and was turned away by four hotels. A fifth took me in. It was amazingly cheap.

'Your capsule is on the next floor; right-hand side, top row at the end.'

You do not get a key to a capsule. I pushed open a door and my heart sank. I was looking at a double bank of washing machines, in one of which I was supposed to spend the night. I located my berth and was surprised to find it womb-like and welcoming. Getting into it was like climbing into the top couchette in a French railway carriage. There was just room enough to sit up in bed, back to the wall, and in this position one could watch the built-in TV screen.

Soaking in the hotel's communal bath I got to talking with some businessmen who invited me to join them for a drink afterwards. We met up in the *aka chochin*, 'red lantern', a typical, simple and reasonably priced drinking-spot next door. When they told me they worked for Nippon Light Metal, I surprised them by relating my meeting with their colleague, Mr Ohira. We ate a lot, laughed a lot, and drank a lot, and they refused to let me pay. If I slept in a capsule that night, I have little recollection of it.

The next day I left my backpack in a coin-locker at the station and took the train back to Okitsu, bent on discovering why an inn that had stayed twenty generations in the same family, that had witnessed so much history, and had been immortalized in a book, should have closed its doors after four hundred years.

9

Japanese inn

Okitsu • Ejiri • Fuchu

TODAY'S JOURNEY was to encompass an emperor, a shogun, a US president, and a gangster. First, however, I needed some new clothes. My trousers were now two inches too big for me at the waist. For the bargain price of 2,900 yen at a men's outfitters in Shimizu I had a new pair of trousers, a T-shirt, two extra holes punched in my belt, and a complimentary can of orange juice. I then took the train back to Okitsu and made straight for the Minaguchiya.

The policeman had told me that it was no longer in business as an inn, and I now vaguely remembered someone telling me this a few years ago. It stands back from the Tokaido behind a high grey wall. The inn had been founded in the sixteenth century during the Warring States period. I was not expecting this ordinary-looking building.

I explained my quest and was invited in. I was introduced to a man in his late fifties; he called for his English-speaking assistant and the three of us sat down at a low table. Iced tea was served. They told me that the inn had closed its doors in 1985. The master, Mochizuki Hanjuro IV, who figures prominently in Oliver Statler's *Japanese Inn*, was now in his eighties and had sold the inn to a forwarding company and it was now being used as a training centre. He still lived next door, but had been unwell for some time.

I was given a guided tour by the younger man. I followed him down a maze of narrow corridors. Everywhere was the cool scent of new tatami and cypress wood. We came to a suite: two large rooms overlooking a garden. This is where the late Emperor Hirohito had stayed in 1957 when on an official visit to the region. The room was empty except for a long, low, red-lacquered table and a glass showcase in a corner which contained, amongst other memorabilia, a photograph of the Emperor standing by his

Rolls Royce in the inn's forecourt.

Something was missing. Statler closes his first chapter with the words, 'I fell asleep to the sound of the sea'. His room, like this one, opened onto the garden at the bottom of which was the seashore. We went into the garden and I looked in vain for the sea. Instead, there was a tall hedge from behind which came the relentless zip, zip, zip of passing traffic. The view from this spot had once taken in Mount Fuji, Suruga Bay, and the fabled pine beach of Miho, the latter traditionally held by the Japanese to be one of their most beautiful sights. What had been the feelings of Mochizuki Hanjuro IV, the last of twenty generations of Mochizukis to run this inn, as the yellow bulldozers arrived to carve a route for the expressway? In such circumstances, does one just say '*shoganai*, it can't be helped'? Farther down the street on the same side, the house of Prince Saionji, last of the *genro*, the founding fathers of modern Japan, had also backed onto the sea. It, however, was safe from the noise and vibration of the expressway; it had been transported to Nagoya to the unnatural calm of Meiji Mura (village), to join Frank Lloyd Wright's Imperial Hotel lobby and a host of other architecturally distinguished buildings for which there is no place in the economic rationalism of today's Japan.

I left the Minaguchiya and went in search of an antidote to my feelings of anger. I discovered it a few hundred yards down the road: a temple founded in 679, rebuilt by Ashikaga Takauji, and set in its final form in 1702. This is Seikenji. It stands high above the Tokaido. Behind its fine main buildings, a garden climbs up the hillside becoming steadily wilder and finally blending into the forest at the top. A path winds up and I was surrounded by the staring eyes, pained looks, half smiles, the enigmatic expressions on the faces of the *gohyaku rakan*, the five hundred Buddhas. I started counting the statues and gave up after two hundred.

Back at the gateway, a haiku referred to the view of Miho no Matsubara from this spot. I looked for the line of pine trees, but it was hazy and I could see only the expressway with its thick concrete supports and behind it cranes and warehouses. Besides, it is not the view from here that is famous, but the view from the beach of Mount Fuji rising out of the sea and framed by the pine trees on Miho's shore.

Miho rocketed to fame when a goddess, attracted by its beauty, descended from heaven and went for a swim, leaving her feathered robe on a pine branch. A fisherman found the robe and refused to give it back until the goddess danced for him. A traveller in the seventeenth century who had read the many poems in praise of Miho recorded in his diary his disappointment at not finding it as he had expected. *Plus ça change...*

I set off along the road towards Ejiri keeping an eye open for a liquor store where I could buy my daily can of Sapporo. At the first one I came to, the choice was overwhelming. There was beer from a dozen different countries, whiskies from every glen in Scotland. The owner, Mochizuki-san, (no relation to the family who had run the Minaguchiya), had made a tour of the Strathspey distilleries and had a collection of rare single malts to prove it. I left with a can of Young's beer, an old favourite from when I lived in London.

The old road passed near Shimizu station and I collected my backpack. I resented its weight, but it meant that I was once more moving on. Ejiri is Shimizu by another name. I had wanted to find the tomb of Shimizu's most famous son, Jirocho, Japan's Robin Hood. He was a gambler, and his gang had controlled this section of the Tokaido; he was a nineteenth-century *yakuza,* an enigmatic figure, considered more good than bad. Like his modern underworld counterparts, he had developed an interest in legitimate business. Among other enterprises, he was responsible for bringing the first English teachers to Shimizu and campaigned successfully for a modern harbour. It was at this port that former US president Ulysses S. Grant was to land in 1879 during his world tour, when he had tried to mediate a dispute between Japan and China over the Ryukyu Islands.

I did not find the tomb. I was now fed up with Ejiri-alias-Shimizu, and I had a long way to go before reaching Fuchu where I planned to stay the night. My route took me past a candy shop unchanged since the Genroku age, around 1700, and where I was invited to drink green tea on the rear verandah overlooking its exquisite Japanese garden. It took me past the site of Japan's first experiments with rockets. A notice-board displayed a primitive device used in one of the battles of the Warring States period in the sixteenth century.

Much of this road was noisy, modern and boring, but the old

road appeared again only to disappear immediately into twelve sets of railway tracks that cut a broad swathe through the landscape. On the far side of the tracks I found a very ordinary-looking road. It felt right. But it was now dark; there were no signposts, and I did not want to waste time getting lost. I knocked at a door. A little girl opened it and led me to a workshop filled with automobile engine coils. Her father explained that he made the coils here and sent them on through the next stage in the motor-trade distribution system. Was this the Old Tokaido? Was I on the right road to Fuchu? His face lit up.

'Yes, indeed, and if you look in that waste ground on the other side of the road, you will see a little stone Jizo.'

According to my very inaccurate map, the road would shortly switch back to the other side of the tracks. I made a half-hearted attempt to follow it but this time I could find no way to the other side. Finding the continuation in the dark was going to be almost impossible, I resigned myself to yet another long boring grind along a modern highway, but a kilometre or so later, I chanced on another section of Tokaido and I walked into the centre of Fuchu on a quiet, narrow road.

I started looking for a hotel. I should have no problem. Fuchu is an important place. It was here that Tokugawa Ieyasu, the founder of the Tokugawa dynasty, had retired after setting up his son as shogun. He had a castle here and at that time it was known as Sunpu.

I checked in at a hotel. Instead of being the only *gaijin*, foreigner, I was surrounded by *gaijin*: young, strong, superbly fit-looking *gaijin*.

'They're here for a track-and-field meet,' the man on the front desk told me. 'Tomorrow we're expecting Carl Lewis.'

Did the Olympic gold-medalist know that he was in the ancient post-town of Fuchu-alias-Sunpu? I doubt it. As far as he was concerned, this was Shizuoka.

10

The Meiji tunnel

Fuchu • Mariko • Okabe • Fujieda

THE DAY STARTED with tea and ended with saké. Shizuoka (Fuchu's modern name) is the green tea capital of Japan. My principal informants for the route of the Old Tokaido were the tea merchants operating from small shops, lined with tea chests, in back streets. Fuchu was a castle town. It was the site of Sumpu Castle, built by Tokugawa Ieyasu in 1589. The roads in this part of the city are constructed on a grid pattern. The old road follows the grid after the manner of a knight on a chess board. This was a classic *masugata*, a device to slow down and confuse an enemy approaching the castle by forcing a series of right-angle turns. Tea merchants' shops would have been key features of the old road. If I was passing their successors today I reasoned I was on the authentic route.

Any of these roads would have brought me eventually to the bridge over the Abekawa river. Trying to follow the original route was not just a purist obsession. It often meant the difference between walking down a street full of drab postwar concrete structures and another, one block away, lined with attractive old samurai houses and traditional shops.

After the bridge, the old road was easy to find. In a small village a lone tree stood with its broad trunk in the middle of the pavement, its branches spreading across the road. I was surprised that it had not been cut down as an obstruction. I asked at a nearby shop if it had any special significance and was told that it had been planted to commemorate Japan's victory in 1905 in the war against Russia. In those days, Japan was Britain's ally, but under the terms of the treaty it fought and won the war alone, confounding the sceptics, and confirming Japan's status as a major power in the Far East.

There was a photocopier in the shop and I took the opportunity to make spare copies of my maps. The owner asked

what they were for and I explained that I was trying to walk the fifty-three stages of the Tokaido. I handed her a 1,000 yen note.

'No charge,' she said. 'It's my contribution to your journey.'

As the road began to climb towards a line of deep green hills it began to rain for the first time since I left Tokyo. Children with bright red satchels on their backs were making their way home from school under large yellow umbrellas. I reached the little village of Mariko. The name is evocative. It is more usually found as a girl's name, and in Clavell's *Shogun*, Mariko is the beautiful young samurai's wife who falls for the Englishman Blackthorne. I had two questions in mind: was Hiroshige's thatched roof tea-shop, with its two customers eating yam soup, still in existence, and would the post-town live up to the charm of its name? The answers were yes and no.

The tea-shop I recognized instantly. It is called the Chojiya. I went inside; it was dark and full of ancient-looking beams and supports.

'Is this the original building?' I asked the master.

He gestured towards two of the rooms.

'These two, yes,' he said. 'And we still serve *tororo*.'

This is a thick soup made from grated and mashed Japanese yam and is the Chojiya's specialty.

The master showed me a magnificent book of old photographs of the Tokaido taken in the Taisho era (1912-26). One showed a horse-drawn caravan disappearing into a narrow brick-lined tunnel.

'That,' he explained, 'is the Meiji Tunnel. It goes straight through the mountain between Mariko and Okabe. It will save you having to cross Utsunoya Pass.'

Mariko is charming, this little part of it. A hundred yards away a different style of architecture became apparent. Mariko's hotels have names like 'Marie-Claire,' 'Hotel 1986,' and 'Fashion'. Their windows are opaque and look as though they have never been opened. The roofs are festooned with neon, battlements and Gothic turrets. The range of rooms on offer are shown by illuminated colour photographs: heavy plush Second Empire velvet-covered furniture in one love-nest, another with hanging creepers and a pool of water, the bed to be reached by swinging, Tarzan-fashion, from a trapeze. Five of the rooms were not illuminated indicating that they were in use. Love hotels were

bad news. It meant I was near a main road and sure enough, the old road which had been a haven of quiet all the way from Shizuoka merged into Route 1, where unbroken lines of trucks thundered in both directions.

I followed the exhaust fumes up the narrowing valley until the highway disappeared into a large tunnel. A roadside noticeboard showed the road to another tunnel, higher up. This road soon became very steep. I came to a tiny village of Edo period houses, the road so narrow I could stand in the middle and almost touch both sides. Higher up it became a gravel path and a signpost gave me a choice: Okabe via Utsunoya Pass and Okabe via the Meiji Tunnel.

It was 5.30 pm and the light was fading fast. The mountain route was out of the question. I reached a clearing. The mountainside vegetation was deep green and luscious except where the path disappeared into a horseshoe-shaped inky blackness. The tunnel was narrow and its entrance was formed by a brick arch. It was like a disused railway tunnel.

At the far end, perhaps three hundred yards away, there was a faint circle of daylight. I stepped in a few feet and at first could see nothing. For the first time since leaving Tokyo I felt scared. In another fifteen minutes the last of the daylight would be gone. I was totally alone. The tunnel's possible horrors flashed through my mind: I would step into a hole, robbers lay in wait, spiders' webs dangled, I would stir up a swarm of bats.

But it was this or back down the mountain to Mariko and a night in the jungle room of a love hotel. I took a deep breath and headed into the heart of the mountain. After a hundred and fifty paces the light at either end was equally small and I broke out in a cold sweat. I began to run towards the light ahead.

Eventually, with immense relief, I emerged into the open on the other side of the mountain. It was dark and beginning to rain again as I walked into Okabe, a well-preserved Edo period post-town. The narrow street was still. There was no traffic. Someone was playing Chopin. Two young boys sat at an open window playing *shogi*, Japanese chess, with their grandfather. A girl knelt on the floor brushing her hair in front of a standing mirror. But I could not see her, only her shadow projected on the paper screen of the *shoji,* sliding window.

A bright light shone from an open door. It looked like a museum of some sort and I went in. In fact, I had stumbled into

a saké brewery. The owner, Hashimoto-san, showed me the ancient wooden vats and the stainless-steel modern ones. I was invited to drink the local spring water.

'It's the secret of our success; we've won top prizes four times in a row including one for the best saké in Japan'.

Before I left he telephoned to book me into a hotel in the next town and as I said goodbye his wife slipped a bottle of saké into my backpack. I reached Fujieda and the heavens opened. I took shelter under an arcade. A car drew up from nowhere and I was offered a lift to the hotel. Two children had seen me walk by in the torrential rain and they had told their father who had immediately got out his car to help me. Neither of us knew where the hotel was and so he used the car-phone to get directions from the manager.

By the time I had changed out of my wet clothes and showered it was late and I was hungry but all the restaurants were closed. The manager told me there was a bar nearby where I could get something. I found it and peeked inside. It turned out to be a karaoke bar and looked the kind where you are presented with a bill equalling a month's salary. I was about to leave when four middle-aged men called out to me to come in and insisted I join them. Whiskey appeared. The mama-san fixed me a pizza.

I told them the story of my journey, and they regaled me with tales of life in Fujieda. They taught me the local dialect. I had to sing a song, and then another, and then another. My timing was bad and I could not read the words appearing on the video screen in Japanese *kana* script quickly enough and so the mama-san whispered them in my ear and beat the time with her hand on my back. Three hours and many drinks later I asked for my bill.

'No!' chorused the four men. As I staggered out into the night, the mama-san gave me a cassette tape. She had been recording us as we sang.

In my room I tried to write up the day's events but in my drunken exhaustion could only manage three lines:

On the old road
The rain is warm
Moving shadows against the shoji

As a haiku in English it did not amount to much but as a purely personal record it captured one moment in an extraordinary day.

11

The Oi River

Fujieda • Shimada • Kanaya • Nissaka

TRAVELLERS on the Old Tokaido had to overcome many obstacles but none greater than the Oigawa. This formidable river between Shimada and Kanaya was swift, wide and prone to flooding. Its difficulty was proverbial. 'Hakone's seven *ri* I can cross on foot or by horse, but the Oi River I cannot cross.'

But today there is a steel-girdered bridge and my only real difficulty would be finding somewhere to stay. I asked the manager of my hotel if he could help. He got out his directory of Business Hotels, selected one in Kakegawa, as there was none in Nissaka, and telephoned to book me a room. I did not write down the name as I thought I would remember it. It was called the Hotel Pastor. That sounded too Christian for a business hotel. Could it be Pasteur? Hardly. He was not exactly a businessman. Anyway, they would know in Kakegawa.

It had rained heavily the previous evening and as I set out for Shimada, a distance of about eight kilometres, it started raining again. There was a massive clap of thunder and for five alarming minutes I took shelter in a timber yard as lightning struck all around me.

I stopped at a window to buy take-away sushi. I handed over the exact money plus three per cent consumption tax... but I was one yen short, a US cent, a British halfpenny. I thought I would be let off, but no, and in the pouring rain I had to search through all my pockets for the missing sum.

The approach to the place where the old road had once forded the Oi River is now a quiet backwater. Some of the buildings from the old post-town of Shimada have been preserved and labelled. They looked well-kept but lifeless and on this late Saturday morning, there were no visitors except me. In fact, a whole week had passed since I had last seen anyone take any interest whatsoever either in the road or the features along it. I rounded

a corner to the gate of a temple and came face to face with a middle-aged couple dressed in hiking clothes, with backpacks and holding plastic map cases. They looked like professors. At last someone sharing my obsession whom I could swop notes with.

Without thinking, I blurted out a *konnichi wa*, hello, and immediately regretted not giving them the opportunity to make the first move. The man returned my greeting very politely and then proceeded at once to inspect the features of the temple, one by one, as if I was not there. It was my mistake. I had come crashing uninvited into their weekend journey into the past.

The road came to an abrupt end and I climbed to the top of the embankment that faced me. A vast flood-plain lay in front of me, perhaps a kilometre wide. In the middle of this the Oi River flowed in numerous channels swirling around miniature islands capped with bushes and trees.

I heard a noise in the undergrowth behind me and was irritated to see that the professor and his wife were now rummaging through a piece of wasteland where they had obviously discovered something of interest. I had become proprietorial and jealous.

My plan was to cross by the bridge after walking down to the water's edge as near as possible to the original fording place. I followed a rutted path across the flood-plain, trying to avoid the many deep puddles. A white car appeared in the distance and came towards me. I stood on the edge of the path to let it pass, presuming that it would slow down through the puddles. It did not. I was drenched. The young man in the passenger seat looked back at me but his expression was blank. Had they splashed me on purpose? I doubt it. I was on foot, they were on wheels. I did not count.

At the water's edge I was not alone. A large, black, luxurious American car was parked facing the river. It had smoked glass windows. I imagined a pair of *yakuza* mobsters carving out their respective territory. This side of the river for me, the other side is all yours. But in fact the front window was open and I quickly averted my eyes from a scene more romantic than conspiratorial. The rain came down *again* and I headed for the shelter of the bridge. As the traffic rumbled overhead I ate my sushi and drank my beer and debated whether to confront the two punks from the white car who were also using the bridge as a shelter for a

noisy barbecue with a gang of their mates. But my mood had
mellowed and I did not want to spoil their fun or give them a
chance to spoil mine.

I finished my picnic and set off across the bridge. It took me
ten minutes at a steady pace. The river below was running fast; it
had split into five channels of swirling brown liquid clay. In the
days before the bridge, when travellers had to wade across, traffic
was halted when the depth reached 145 cm. This happened
frequently and was good news for the innkeepers of Kanaya and
Shimada, as clients waited days for the floods to subside.

I walked back downstream for a hundred yards and was
delighted to find the continuation of the old road at
approximately the site that I had calculated from the other side.
The road rose steadily towards a small town nestling halfway up
a hillside, beyond which was a mountain ridge. Clang, clang,
clang. I was stopped by the yellow and black striped bamboo
pole that had come down across the road at a level-crossing, and
to my amazement a quaint and rather ugly steam locomotive
chuffed backwards across the road pulling three ancient wooden
carriages.

Above Kanaya the road became steeper and steeper, at first
cutting through twentieth-century suburbia with occasional Edo
period surprises, then through a dark forest where ribbed
concrete alternated with stone pavement. At the top, breathless,
I turned right at a monument to Basho, the master of haiku, and
followed the ridge past a dilapidated and boarded-up tea-house,
an NHK, national broadcasting company, TV transmitter, an NTT
telephone company relay station and the ruins of a castle, at
which point I got lost. The road ahead appeared to run through
a tea plantation. I had a choice of a modern road, which I
instinctively avoided, and numerous paths between the tea
plants. One of these ran into a small wood and I wanted this to
be the Old Tokaido. I was soon rewarded by a cluster of stone
statues half-hidden by the road side and just as soon punished
when it came to a dead end. I eventually found a path that
descended dizzily, sometimes through long, waist-high roly-poly
rows of green tea plants, sometimes through dense bamboo
groves. It may or may not have been the Old Tokaido but the
scenery was magnificent and I had it all to myself.

I came to a T-junction marked by a stone lantern. An aged

farmer's wife pointed me in the direction of Nissaka. The road ran straight between rice fields. It was now almost dark; ahead of me near the edge of the road, but standing in the rice field, was a farmer. He wore a straw hat and a yellow T-shirt and stood facing me as I approached. I wanted to exchange greetings but I let him make the first move. He ignored me completely. I looked back and saw that he was a very neatly dressed scarecrow.

I reached a village on the main road and went into a shop. It was full of *omiyage*, the souvenirs Japanese bring home to their family and friends from their travels. Most of the items featured Hiroshige's 'Nissaka'. This is the print that shows travellers at the bottom of a hill inspecting a large boulder in the middle of the road. I bought a souvenir for the sake of the label and asked if there was a bus to Kakegawa. The proprietor offered to give me a lift. I sat in the back of the car driven by her daughter. They took me to the Pastora, a luxury hotel. I told them mine was a small business hotel. We eventually found it in a sleazy backstreet near the station. It was called the Pastel.

The lighting in the lobby was subdued, my key had a purple tab and the corridors were lit with purple bulbs. My room had red flock wallpaper, an electric green carpet, a love-seat set in an alcove, and twin king-sized beds. I sat on the love-seat and made my plans for the next day: a trip back to Nissaka to try to uncover Hiroshige's boulder, hidden perhaps in the undergrowth in some forgotten piece of wasteland.

12

The night wailing stone

Nissaka • Kakegawa • Fukuroi • Mitsuke • Hamamatsu

I HAD BROKEN my journey somewhere short of Nissaka and had spent the night in Kakegawa, so I was a stage ahead of where I should be. To get to the point where I had left the Old Tokaido, the simplest way was to take the train back to Kanaya.

At the castle ruins where I had lost the road the previous day, I tried another route. The views were once again spectacular and again I found myself at the stone lantern. Three hundred yards farther on I found an original Tokaido signpost, a stone pillar inscribed with the *kanji* for 'right' and 'left'. My direction was to the left. I was once again on the right track.

Today's quest was the steep hill depicted by Hiroshige in his print entitled 'Nissaka', and subtitled 'Sayo no Nakayama'. At the bottom of the hill, travellers are seen inspecting a large boulder in the middle of the road that looks as though it has rolled all the way down from the top.

I arrived at another junction. There was no signpost. The most likely candidate for the hill lay to the left. I kept my eyes open for possible boulders, but if my orientation was correct, the valley Hiroshige had drawn was more likely to be the one on the other side of the hill. The road to the top was concrete. It was ugly and somehow 'wrong'. Any of the surrounding hills could be the 'middle mountain' (Nakayama) of the print's title. However, at the top, the road entered a grove and passed between a shrine and a temple. The *torii* and the temple gate were both covered in pale green moss. This, together with the puddles and the dripping leaves, contributed to a forlorn atmosphere of decay. The one feature of the temple that was not covered in moss was a stone, a large stone: a boulder, in fact. It sat about three feet high, under a little open pavilion structure, presided over by a bronze statue of a Buddhist monk.

Once upon a time, a pregnant woman was travelling this way. She stopped to rest on a stone. A robber was lying in wait. He attacked her with his sword, damaging it against the stone in the process. As she lay dying, she gave birth. The baby was found by a Buddhist monk who brought the child up to be a master swordsmith. The woman's spirit, meanwhile, had entered the blood-stained stone and each night the stone could be heard wailing. This is why it is called the *Yonaki Ishi,* the stone that cries at night.

Years later, the robber took his sword to be mended. Foolishly, he confessed how the damage had occurred. The master swordsmith avenged his mother's death by felling his customer on the spot, with a single stroke.

The descent from Sayo no Nakayama was beautiful. There were no cars, and bamboo groves alternated with tea plantations. All around rose green hills, and then darker green hills, and then a range of misty blue mountains. In the village of Nissaka, I sketched a Hiroshige bridge. The scene had changed little and I had further evidence to support the hypothesis that Hiroshige is much more faithful to the geography of his landscapes than he is usually given credit for.

The road descended towards Kakegawa through yellow ricefields set in saucer-shaped hollows between wooded hills. Suddenly I was in a town.

'Welcome!'

This in English from a young man with short frizzy hair, wearing neatly creased black trousers, white shirt and bow tie, standing beside the pink sign at the entrance to a dubious-looking dive. He handed me a pink card. His establishment offered unspecified 'pleasure' for 3,000 yen.

Kakegawa is another castle town and I wanted to follow the complicated left and right turns indicated on my map; I made a ritual series of right-angle turns, found a temple, got lost, went back and tried another combination of right-angles and found a small wayside shrine near the 'pleasure' shop. A shoal of schoolgirls in immaculate white blouses and blue pleated skirts swept by on their bicycles with long *kyūdō,* Japanese archery, bows in canvas cases slung over their shoulders.

In my hotel, I turned on the television and was intrigued to see one of the rivers in Shizuoka that I had recently crossed. The

raging current was about to top the sandbags, and a small wooden house came floating down as if it were a canoe shooting the rapids. The next item concerned an approaching typhoon. It was still a long way away, but it was pushing a storm front ahead of it and the forecast for the region was more heavy rain.

The next morning I set out to walk to Hamamatsu. Between Kakegawa and Fukuroi the road was wide, busy, and boring. The old road was there somewhere, but I had missed it. When I did find it again, it took me past the gates of Fukuroi Higashi (East) Primary School. My attention was drawn by the garden, an elaborate affair of paths, ponds, flora, and various ornaments, the whole somewhat incongruous against the drab rectangular concrete school building. A teacher invited me to wander around. Soon, I was surrounded by children, the boys in white T-shirts and white shorts, the girls in volleyball kit, their names in large kanji on their shirt fronts. The girls with their long suntanned legs seemed more like High School students than Primary School kids. They were bashful and demure. The boys larked around and each time I took a photograph they tried to get in the frame. I looked back as I left and there was a child waving from every window on all three floors.

Do the Japanese walk the Old Tokaido today? I found the answer at a small roadside restaurant called Sakaguchiya, in Fukuroi. The owner told me that a local newspaper had organized a Tokaido walk in the holiday-studded late spring 'Golden Week' and that many of the walkers had stopped by for lunch.

From Fukuroi to Mitsuke, the road was lined with pine trees. It was rain-swept, and deserted. As I walked down the hill into Mitsuke, a car came tearing around a corner, slammed on its brakes, and skidded for twenty metres along a wall with a horrendous noise of metal scraping against stone. The driver was about twenty. He sat in the car looking shocked. As far as I knew, I was not the cause or at least was not to blame; I had been walking by the edge of the road, facing the oncoming traffic, and I was wearing the yellow armband with a reflective silver patch that I had noticed schoolkids wearing to make themselves more visible on the dark roads.

Mitsuke has many interesting buildings, including one unlike anything I had ever seen in Japan. A three-storey structure, brilliant white with pale olive-green woodwork, a curious pattern

of uneven lengthed black quoins and topped with a feature that was a cross between a gazebo and a pagoda. It had been built in 1877 and was one of the first elementary schools established after the official adoption of Western culture in the early 1870s.

As I approached the bridge across the Tenryu River in the fading light, it started to rain. I had seen the dark cloud looming, but nothing had prepared me for the rain's suddenness and volume. The road became a river and within a minute the water was up to my ankles. My small folding umbrella was useless and I was soaked to the skin. The bridge was extremely narrow and there was no footpath. It took ten nerve-wracking minutes to cross against the relentless oncoming headlights. Frequently, I had to squeeze against the girders to avoid being scraped by an extra-wide truck. Mentally, I made contingency plans in case I was forced onto the parapet and from there into the angry, swirling, dark mass of water beneath me.

I reached Hamamatsu by bus, the rain and the dark and my shattered nerves having forced me to cheat for the last two kilometres. In the comfort and safety of my hotel room, I exchanged my sodden clothes for a crisp *yukata*, light summer kimono, and reflected that somewhere near Mitsuke I had passed the halfway mark between Tokyo and Kyoto. I was now on the home stretch.

I turned on the television to find a satellite view of Japan, dominated by the spiral cloud mass of a monster typhoon. Typhoon 19, it was said, was the most powerful in twenty years. If it continued on its present course, and at the same speed, it would reach the Old Tokaido the following evening near Toyohashi. And so, if I continued at my speed, would I.

13

Typhoon 19

Hamamatsu • Maisaka • Arai • Shirasuka • Futagawa

THE TOKAIDO once loomed large in the popular consciousness and it gave rise, for instance, to a large number of Edo period board-games. In one that I heard of, players would start on square one at Nihonbashi and run the hazards of the fifty-three stages down to the Great Sanjo Bridge in Kyoto. It was an early form of Monopoly in a way. Most of the time you landed on a post-town square but every so often you hit a high-value castle-town, such as Odawara, Fuchu (Shizuoka), Kakegawa or Hamamatsu.

Kinks in the road were part of the castle's defence system, and I spent a fruitless hour trying to locate them in the modern roads of central Hamamatsu. Of the castle, visible in Hiroshige's print in the backround to the right of the tall roadside tree, there remained only ruins.

Eventually, I gave up and headed out of town on Route 1. The road was busy and boring. Four kilometres out of Hamamatsu, the main road took the traffic curving off to the left. Ahead was a broad, pine-lined and quiet avenue which continued almost dead straight for the next four kilometres

(The path of the Old Tokaido can be seen from the Kyoto-bound Shinkansen as a long line of trees, on the left-hand side just after Hamamatsu, stretching to the shores of Lake Hamana.)

Pine trees offered me one way of identifying the old road when there was no written indication, which was the usual case. They were planted to delineate the route and to provide shade for travellers. Another was to go by its characteristic buildings: shrines, temples, primary schools, and — as I had begun to notice — private hospitals and clinics. The latter are often housed in large European-style clapboard mansions of the Taisho era, one of which I saw just before Maisaka.

Maisaka was once a crucial ferry landing-stage and fishing port. The ferry has gone but the road still comes to a dead end at

the point on the lake where the landing-stage stood.

Lake Hamana was once separated from the sea by a narrow strip of land, but an earthquake in 1498 broke the sand-bar causing a two-hundred yard gap and the breach is called Imakiri ('now cut'). The two sides are now joined again by the long, gracefully rising and falling curve of a modern bridge.

I stood on the sea-wall to watch the sunset and to compare the scene with the Hiroshige version. A less successful addition is a red *torii* gate standing, as at famed Miyajima, in the waters of the lake. Unlike the *torii* at Miyajima, this one is made of concrete and stands out self-consciously picturesque and without any obvious connection to its shrine, if indeed there is a shrine.

On the lake shore a bilingual notice gave advice to swimmers: 'A warm-up will help you good,' and 'Do not swim when drunken'. Concrete and plastic coconut-palm sunshades stood rigid and forlorn on the deserted beach overlooked by hotels with the severe rectangular outlines and unrelieved concrete texture of company dormitories.

Edo travellers crossed Lake Hamana from Maisaka to Arai, a distance of four kilometres, by the Imakiri ferry. I walked inland and crossed by way of the causeway and bridges that carry Route 1 and the Shinkansen tracks. Night was fast falling. On my right the dark was illuminated at five-minute intervals by the multiple blue sparks from the Shinkansen pantographs; on the left the yellow neon double arches of a McDonald's drive-through stood out against the twilight sky.

Typhoon 19 was forecast for some time in the next twenty-four hours. I had friends to see in Toyohashi, not too far away. It seemed sensible to set up base there, so I took the train from Arai and found a cheap business hotel a few minutes from Toyohashi Station.

There was still no sign of the typhoon the next morning, so I took the train back to Arai and went straight to the old checkpoint. This once stood on the shore of Lake Hamana, but now lies two kilometres inland. The main feature of the museum that stands on its site today is a collection of one hundred and eighty-nine original Hiroshige prints, one of which depicts the Arai landing-stage and checkpoint.

As I came out of the museum it started to rain, and by the time I had crossed the road it had become a downpour. I took refuge

under the awning outside a stationery shop. For fifteen minutes I watched the rain, and counted five motorists who made no attempt to slow down through the very obvious puddles and so drenched the hapless pedestrians with their spray.

The shopkeeper took pity on me and invited me into the apartment above the shop. The Hashimotos were a young couple. The stationery shop was their main business, but their real love was pottery. Kiyotaka threw pots in a style influenced by the illustrious potter Hamada Shoji, while Kumiko favoured an 'ethnic' style. They served me tea. The rain continued. They gave me lunch.

'So why is your English so good?', I asked Kiyotaka-san.

'I went to a language school in Tokyo. The teachers were all from Britain. My teacher's name was Roger.'

It was ILC, the school where I had taught for my first five years in Japan. I knew Roger well.

Two hours later, the rain was still coming down in buckets. This was not the typhoon proper, just the rain front. Against the Hashimotos' protests I set out for the next stage with a gift of their pottery, a pair of chopstick rests, in my back-pack.

The rain eased and stopped, and started again as I passed a supermarket. The whole staff including the manager came outside to look at the rain it was so heavy. Giggling, the shop assistants agreed to pose for a photograph. Just as suddenly it was all clear and I set off again.

The road to Shirasuka runs steadily closer to the sea. Route 1 and an elevated highway along the beach carry the traffic, so the old road is quiet. Three schoolgirls came by on bicycles, stopped thirty yards ahead, held a conference amongst themselves and then rode back.

'Don't you know there's a typhoon coming?' they said in unison.

They had been sent home early from school and were clad from head to toe in smart pale yellow weatherproofs.

Shirasuka is a long, strung-out post-town. Most of the houses are wooden and appeared to be from Edo or early Meiji days. There were few signs of preparation for the coming storm: a board fixed at the foot of one door to prevent flooding; a man on a ladder nailing down a length of loose fascia.

The road came close to the sea. I walked to the beach under an

unfinished length of elevated highway. The sky was a leaden grey and the wind became noticeable for the first time, kicking up high waves that crashed rhythmically against the shore.

I made my way back to the road which turned inland and uphill.

This slope is called Shiomizaka. A woman in the town said I would find Hiroshige's viewpoint at the top of the hill. When I got there a farmer said I would find it halfway down towards the sea. They both could be right: Hiroshige sketched this vista many times from different viewpoints. For me the scene was most memorable for the thunderous noise of the *suzumushi,* cricket-like insects, as the road passed through a dense bamboo grove.

But at the top of the hill I was more interested in the sight ahead of me: great black clouds sweeping at great speed over the foothills five miles ahead.

I arrived at Futagawa at 6.00 pm. The storm seemed imminent but always five miles away. From Futagawa I took the train to Toyohashi, thankful that I already had a hotel to go to, right by the station.

At my destination two young women were standing at the top of the stairs from the platform nudging each other and laughing nervously. I had noticed them sitting opposite me in the train. The prettier of the two approached me as I came level.

'Do you need any help?' she asked in perfect English.

'No, I'm okay. Why?'

'You look so tired.'

They walked with me to the ticket barrier and we chatted a while at the station entrance.

They said goodbye and as they turned to wave a last time they called out to me to be careful as the typhoon was due any moment.

It came thirty minutes later and caught my friend Anthony as he was crossing the square in front of the station to reach my hotel. The cloudburst was so great and so sudden that I had to lend him a set of dry clothing before we could set out to try to get to the restaurant of the Hotel Terminus. This involved a thirty-yard dash to an underpass and from there to the hotel. We arrived drenched and bedraggled and fully expected to be refused entry to the plush and sophisticated Sky Lounge. Instead, we were given a warm welcome. We were, and remained all evening,

the sole clientele. As the rain dripped from our clothes to the thick carpets, we sat back with our drinks and enjoyed the view of the gathering storm over the roofs of Toyohashi.

The return to my hotel was no longer a joke. A bus shelter had collapsed; a metal signboard came flying past; the rain was torrential and virtually horizontal. Making headway against the wind required a massive effort.

In my room I tuned in to the NHK typhoon special, scheduled to give storm updates all night. A map came on showing the paths of three previous post-war September typhoons of similar magnitude. The eye of this one, Typhoon 19 of the season, was forecast to pass somewhere between Toyohashi and Nagoya in the early hours of the morning. I slept fitfully, woken frequently by the continuous roaring of the wind and the high-pitched rising and falling whistling noise through the seals of the metal window frame.

14

Sorobans, palanquins and post-towns

Futagawa • Yoshida • Goyu • Akasaka

I WOKE TO an uncanny silence and brilliant light shining into my room. I switched on the television to find that the eye of the typhoon had passed somewhere north of Nagoya. All that remained here was a blustery wind and a cloudless blue sky.

To get back to Futagawa where I had broken my journey, I needed to take a train. The platforms at Toyohashi station were full of salarymen, and children in school uniforms; the tracks were empty. The station-master, in an immaculate white suit and white peaked cap with a red band, bowed and apologized that because of the typhoon and subsequent landslides, there would be no trains for at least an hour. The shoolchildren waited, squatting in circles, boys in one group, girls in another. They looked happy. The salarymen looked glumly at their watches.

I went to look for a bus, could not find one and so tried to hitchhike. Most of the drivers ignored me. Some waved their hand from side to side in front of them, with that expression on the face known to all hitchhikers that says, 'I'm not going where you want to go,' or 'I'm not insured for passengers,' or (as I felt) 'I don't approve of hitchhikers and especially not *gaijin* hitchhikers your age.'

A car stopped at some traffic lights. The driver had the sullen air of an off-duty *bosozoku* gang member, his expression halfway between blank and aggressive. His driver's window was down and I decided to take a direct approach. I asked if he was going to Futagawa and if so would he give me a lift.

'*Yorokonde*, with pleasure.'

I got into the passenger seat beside him.

'I like *amesha*.'

This was his opening conversational gambit, spoken in English.

'I used to have a Ford Mustang,' he continued in Japanese, `but

then I got married and when my child was born I sold the Mustang and got a Honda Prelude.'

I had learnt a new word: *amesha*. *Ame* for American, *sha* means car. Makino Taro was good company and a careful driver, and the journey to Futagawa where he worked as a panel beater was all too short.

Futagawa is today a small village. There are one or two nice old houses and shops and a potentially impressive *honjin* (the inn where daimyo stayed), which was being restored and was covered in scaffolding and plastic sheeting. From Futagawa to Yoshida the old road had become, in parts, the sidewalk to a modern road. Nearer the centre of Yoshida, streetcar tracks joined the Tokaido, and one of Japan's few remaining streetcars clattered by, stopping to pick up passengers waiting on a central island.

I went into a shop to buy film and to check whether I was still following the path of the *Old* Tokaido, as the road was now broad and featureless. I was told to ask the teacher next door who was sure to know. I knocked and was given an effusive welcome by a youngish man who proceeded to draw a series of maps for me showing where the old road deviated from the new. We were standing in his garage.

'That's my Mini Cooper. A lovely car. But come and see upstairs.'

He took me up to a large room with rows of small tables and chairs. At one end was a blackboard and on top of the teacher's desk was the largest *soroban* , abacus, I have ever seen, ten inches high and at least a yard long.

'This is my soroban school,' he said, and with quick flicks of the big yellow counters he gave me a brief lesson on this jumbo-size class demonstration model Japanese abacus.

'Come and see the downstairs.'

He led me into a room whose four walls were filled with *ukiyoe* prints.

'What do you notice?'

Somewhere in each of the prints there was a soroban.

Oka Hajime is an enthusiast. The children who attend his school are well cared for. Each one wears the school's special yellow reflective sash for the journey home in the evening after dark. As I left he gave me one of these as a present, as well as a pocket soroban, and pointed me in the right direction for

the centre of Yoshida.

Yoshida is a castle-town and the old road followed the usual defensive pattern of right-angle turns. Without an accurate map it was difficult to follow the original route on the grid of modern streets and I made no attempt. An avenue of willows, half of them knocked flat by the storm, led to the city centre. I made for the hotel where I had spent the night, picked up my backpack, and headed for the bridge over the Toyo River; Toyohashi (*hashi* means bridge) is the name by which Yoshida is known today.

Most of the rivers I had ever seen in Japan were little more than pathetic trickles in the middle of absurdly wide flood plains that were sensibly put to good use as baseball diamonds and unofficial car parks. Today, there was no sign of the latter, just a tumbling mass of rapidly flowing, mud-coloured water reaching right up to the raised flood banks.

From the middle of the bridge I could see, downstream, clusters of tall trees facing each other on opposite sides of the river. This could be an indication of the site of a former bridge or ferry. I followed the river bank until I came to the trees. A short stretch of stone pavement led up to a large corrugated iron barn. From the inside with its massive wooden supports and beams, it looked like a medieval English tithe barn. Two men were humping bags of rice from a trailer onto pallets. When they saw me looking round, they pointed towards the ceiling. In the dim light I made out two *kago* hanging from the main beam.

The *kago*, a type of palanquin, was the main form of transport on the Old Tokaido. Daimyo travelled in the more elaborate versions – a fully enclosed structure with windows. These were the more flimsy, open contraptions attached to a pole. They would have been carried on the shoulders of two bearers. There was room for one small person to sit cross-legged and he or she would have to hang on to a strap to avoid falling out.

One of Hiroshige's more delightful Tokaido prints shows a man crossing a trellis bridge. He is leaning forward to make headway against the wind. Another man is running in the opposite direction. He is chasing his hat which is in danger of being blown into the river. As I crossed the bridge over another river my hat was blown away by the wind which had been gusting all morning. I chased it to the end of the bridge. I almost had it in my hand when a stronger gust took it over the edge. It

fell on the river bank from where I was eventually able to retrieve it. There was not a single cloud in the sky and under the hot midday sun I knew that without a hat I would soon be suffering sunstroke. Meanwhile, the aftermath of the typhoon was visible everywhere: a new car covered in mud, abandoned, with one wheel in a ditch; whole fields of flattened rice plants; branches torn off and lying across the road.

Anyone who wants to see a typical Edo period post-town is usually directed to the Nakasendo, the inland mountain route between Tokyo and Kyoto, where several Edo post-towns (in particular Tsumago) still exist, perfectly preserved in amber. Tokaido post-towns on the other hand, the few that remain more or less unspoiled, have an everyday lived-in look. I came to two of these in quick succession. The Edo period buildings of Goyu and Akasaka are ordinary shops and houses. The structural pattern is latticed wooden windows and doors, with above, a short tiled roof, a second latticed storey and then the long top roof, at an angle up to the ridge. People live and work here so there are air-conditioner units standing incongruously on the tiles of the short first storey roof. The Hiroshige view in Goyu can be pinpointed almost exactly by the right-hand curve of the road. The buildings look much the same except for aluminium drainpipes and air-conditioner units, and all but one of the inns have disappeared. No longer do the female staff, maids-cum-prostitutes, go into the street to drag in their customers.

Post-towns are typically eight kilometres (a two-hour walk) apart. Of the fifty-three stations, Goyu and Akasaka are separated by the shortest distance, less than two kilometres of beautiful pine-lined road where, when I walked it, the traffic consisted of one car, one bicycle, and a tractor.

It would have been satisfactory from every point of view to have stayed at the inn in Akasaka. Up till now the only time I had stayed overnight on the Old Tokaido itself was in the love hotel in Kakegawa. Alas, the ancient inn was full, and besides, it was beyond my budget. I went to Akasaka station and took a series of trains to where I knew I would find a reasonable hotel: Yoshida-alias-Toyohashi.

15

Fascist salutes and a ghost town

Akasaka • Fujikawa • Okazaki

'TYPHOON LEAVES TRAIL OF DEATH AND DESTRUCTION.'
I read these headlines in the *Japan Times* in the train on my way back to Akasaka. It had been the most powerful typhoon in twenty years, but compared with the tens of thousands who had died in typhoons of days gone by, the number of fatalities was small. Perhaps all that land-stabilizing concrete that disfigures so many river banks and hillsides really was necessary to save lives and homes from flooding and landslides.

Outside Akasaka, the Old Tokaido ran past a large school playground. It was a junior high. The children were all dressed in the same immaculate sports uniform and were marching around the playground in ordered columns of thirty. A teacher stood to attention on a raised platform. As each platoon passed him all eyes turned smartly right and thirty arms were outstretched in a stiff-arm salute. A gardener cutting the grass with a motorized scythe turned out to be the geography teacher, and he told me they were rehearsing for sports day.

The image of these 13-15-year-olds, giving what looked indistinguishable from a Fascist salute kept returning to me for the rest of the day and I wondered why the government did not at least discourage the practice, if not, as Germany had done, ban it entirely. I put it down to naïvety and ignorance. Japanese frequently worry about foreigners' opinions of their country, yet when I have expressed mild surprise at the 'fascist' salute they often fail to see any problem.

The road ran on through fields of ripening rice, yellow atop green. The crops were criss-crossed with flashing red and silver tinsel. In one field ahead of me a farmer was raising and lowering his arm to activate a whole series of these bird-scarers. When I came level with him he turned out to be a battery-operated mechanical scarecrow, a perfect model dressed in clean, neat clothes.

Outside a primary school there was a tin container attached to a lamp-post. It held a bunch of small yellow flags on sticks which were for the children to carry to make themselves more visible when crossing the fifteen foot width of the Old Tokaido, devoid of traffic and indeed of any sign of life.

I passed a traditional Japanese farm-house, a series old buildings surrounding a courtyard. An item of furniture, a flight of wooden stairs with drawers built into the risers, the sort that sell for a fortune in Tokyo antique shops, lay dusty and unused in a corner.

I crossed over a rushing stream. A heron rose from the water and settled again just around a bend in the stream. I climbed over a fence and tried to follow the bird upstream. Each time I came near it flapped off again and settled just out of sight. I was now in deep undergrowth. I turned to go back to the road and realized with horror that I had lost the plastic case holding all my maps and my pocket Tuttle edition of Hiroshige's Tokaido views. Inaccurate though the maps were, they were all I had. I could easily buy a modern map but nothing that showed the path of the Old Tokaido. I remembered consulting the map just before crossing the stream so it lay somewhere in the intervening hundred yards of undergrowth. My search became more and more panicky and unsystematic until with a cry of delighted relief I found it at the fence by the roadside.

Distances between post-towns vary considerably. Goyu and Akasaka are exceptionally close to each other, whereas the distance from Akasaka to Fujikawa is somewhat above average, so in this case there is a halfway stage. Its name is Motojuku, and it proved to be full of interest. In the middle of the village there stood a large granite *ishidoro*, stone lantern. Near this and with a long frontage directly onto the Tokaido was a Meiji era structure of black woodwork and whitewashed walls, an ancient factory or perhaps a brewery. The double-doors were wide open and I wandered in. Everywhere were old urns and churns and vats, abandoned implements, rusting and cobwebbed machinery, cogs and crown wheels and driving shafts forever motionless: an industrial archaeologist's paradise. It was like a stage set for some version of a Dickens' novel, except that the stage designer had gone overboard in a melodramatic attempt to convey decadence and decay.

On the other side of the street, behind the stone lantern, was

a large two-storey building in the clapboard style popular in late Meiji-early Taisho. Again the door was open but nothing seemed to be happening inside. It looked as though it had once had an official function, as a post office perhaps or a town hall. The empty inner rooms were surrounded by a corridor which was full of junk, old tables and chairs and desks, farm implements, and an antique hand-pumped fire engine. Its wheels were detached and standing against a wall and the pumping mechanism and water tank and hoses were covered with a thick layer of dust; I wanted to ask someone about this building and the abandoned factory but there was not a soul in sight. It was like a ghost town.

Continuing my journey towards Fujikawa I saw a couple wearing backpacks and hiking gear approaching. We were alone on the road. When we reached the prescribed distance from each other at which Japanese hikers say '*konnichi wa*' the couple turned sharply right without a word and started to inspect the gateway to a temple that just so happened to be there. It was the professorial-looking pair whose Edo era idyll I had so effectively destroyed at Shimada.

At Fujikawa I more or less accurately identified the site of a Hiroshige view from the rise and fall features of the road and was pleased to have my identification confirmed by the curator of a tiny museum whose main display was a model of Fujikawa post-town in its heyday. I was the museum's first foreign visitor and the curator was eager for me to sign the visitors' book, which I did giving my London address.

In the last three post-towns I had noticed a number of small-scale textile businesses. The curator told me that cotton was an important local industry and that he himself was in the business, looking after the museum only part time.

It was in this small town that I first became aware of the number of cars left parked driverless but with their engine idling. Once I became aware of this curious habit I began to notice it everywhere and it became an irritant. Since car exhaust fumes contribute to just about every form of environmental pollution it seemed to me that the very least car drivers could do was to turn off their engine when they left their car, even for only a few minutes. In most Western countries leaving the engine running would be an open invitation to car theft.

At Yamanaka I had my picnic lunch in the shade provided by the trees in the overgrown precinct of an abandoned temple to

which I had been attracted by two long rows of stone Jizo, each wearing a different colour bib, green, white, red, or blue. These stood in a niche under the wooden eaves of an earthenware wall between the precinct and the road.

At another temple a group of children were standing around a small bird bath. They called to me to come and look at a long stick-insect. They were nine year-old girls in immaculately laundered white shirts and brightly coloured skirts, and who looked as though they had stepped out of a TV commercial for detergent. They were a happy looking, unselfconscious bunch, no giggling, no shy turning away. They asked me questions politely and answered mine, and when I asked them to pose for a photograph none of them formed the, 'V' for Victory 'peace' sign, *de rigueur* in Japanese group photographs. In two years' time they would be going to junior high and learning how to march in platoons and make stiff-arm salutes.

A long straight stretch of empty road ended abruptly at a wide, fast-flowing river. With suitable footwear it would have been easy to wade across because the old fording site was now a series of shallow weirs and three or four men were standing in the middle of the river with fishing rods. I crossed by the bridge and found the continuation of the old road marked by a stone lantern. This had once guided travellers as they forded the river, particularly at night with its flaming oil lamp, but it was now hidden behind trees and houses.

Towards Okazaki the old road merged with a busy modern highway, lined with monster billboards, many of which had been blown down. The old road was marked on my map but it was now dark and I had lost the trail, so I decided to call it a day.

In my hotel room there was a notice under the heading 'Grime [sic] control'. 'Keep your door locked at all times. Do not allow strangers into your room.' Another notice stated: 'There is a bar on the ground floor but you are free to drink in the refrigerator.' I chose the bar, which was a mistake because I was the only person on his own, and I was surrounded by animated groups to which there was no entrée. I took refuge in my pocket Hiroshige and looked at the scenery to come. At Chirifu there was the horse fair with prospective customers colluding under the 'conference tree'. At Yokohama there is a tree which is descended from the one under which Commodore Perry signed the treaty of amity between the USA and Japan in 1854. It would be nice to find the tree at Chirifu similarly preserved.

16

A divine wind

Okazaki • Chirifu

OKAZAKI WAS NOT where I had spent the night. I had long got used to the idea of not finding a place to stay on or near the Tokaido. Each night I found a hotel wherever I could and I did not care what form of transport I used to get to it. The important thing was always to begin the next day's journey on foot at the exact spot where I had left off the previous evening.

So it was that a bemused taxi driver followed my directions from Okazaki station and deposited me at a nameless, featureless spot on a busy main road. One side of the road was lined with secondhand car showrooms. On the other side, on a traffic island and separated from the main road by low bushes, was a grassy path, about eight feet wide and fifty yards long. A simple modern white granite stone by the side of the path bore the three Chinese characters for Tokaido.

Taking my bearings from the alignment of the path, I followed a side road which ten minutes later ended at a T-junction and a wide-open space bordered by trees on the right and by a dignified wooden structure on the left. It was a two-storey building in the European classical style popular in the late Meiji era: all pediments and porticos and architraves. It was too big to be a private residence and I guessed that it had once been a town hall. It was an unusual and elegant building and perhaps a combination of its size and local affection had prevented it from being carted off to join the collection of beautiful but redundant buildings at Meiji Mura.

Inside, I met a retired schoolmaster who showed me around. It had been built in 1913 as the town hall of Okazaki and was now a museum of local history. There was a scale model of Okazaki castle, its donjon and many turrets occupying most of the original town.

After I left the museum, the old road took me close to the

castle ruins. I should really have made a ritual visit but I had started the day late, spent far too long in the museum, and besides, I was anxious to locate two Hiroshige scenes: the bridge at Okazaki and at Chirifu the site of the *umaichi*, the annual horse fair, when buyers came from all over Japan to do business under the *dango matsu*, the conference pine.

I really should have visited the castle. After all, this was where Okazaki`s most famous son was born, Matsudaira Takechiyo, arguably the single most important figure in all Japanese history. The son of a relatively weak daimyo, as he himself became more powerful he moved his headquarters eastwards: to Hamamatsu, then Shizuoka, and finally to the village of Edo. In the process he changed his name many times. The name he finally settled on was Tokugawa Ieyasu, the founder of the dynasty of Tokugawa shoguns that reigned from 1603 to 1867.

I came to the bridge over the Yahagi River. This was once the longest bridge on the Tokaido. Perhaps for this reason it figures prominently in Hiroshige's prints. Sometimes he sketched it from a high viewpoint, where the focus is on the castle and the distant hills; in other prints he sketched at the level of the river and the focus shifts to the river traffic and the bridge itself. By lining up the features of the near and distant hills with what remains of the castle, and guessing the probable site of the original bridge, I was able to stand close to where Hiroshige must have stood a hundred and fifty years earlier. From there I made my own sketch. When I had finished I realized that I had made an addition to the castle by borrowing a feature from Hiroshige. In my sketch I had drawn on the top of the one remaining turret twin *shachihoko*, dolphin-like creatures, standing on their heads, tails high in the air. They were talismans to protect castles from fire. I had greatly exaggerated the much smaller figures visible today.

At the far end of Yahagi Bridge there is a statue group that commemorates an important meeting. Had this chance encounter not taken place, Ieyasu might have merited no more than a footnote in the history books. An aide to Oda Nobunaga, the paramount ruler in central Japan, was passing over the bridge when he came across a monkey-like young man squatting by the roadside. Toyotomi Hideyoshi, penniless, had left his peasant farmer's home at the age of fourteen to seek a military career. As

a result of this meeting he joined Nobunaga, and rose to become a great general in his service. He even seized the reins of power after Nobunaga's death and did a deal with Ieyasu by which Ieyasu was given Edo, a backwater fief controlling the remote Kanto plain. And the rest, as they say, is history.

On the opposite side of the river from Ieyasu's castle stand two long, tall, rather forbidding wooden warehouses. Edo? Meiji? I wanted to see inside but the great doors were padlocked.

Two roads diverged from the end of the bridge. One was lined with contemporary concrete box architecture, the other with traditional wooden houses with double roofs and grey tiles. This was the old road to Chirifu. I stopped at an Edo-period shop to buy *onigiri*, pickles or tuna embedded in rices balls wrapped in seaweed, for my picnic lunch which I ate later on a grass verge between rice fields near the edge of the town.

Walking down the side roads of Japan is as good a way as any to learn about the economic basis of the country. Numerous small-scale industries function in the most unlikely places. I became an expert in recognizing the difference between T-girders, H-girders and box girders. In her front garden a woman in her sixties, her head covered like a beekeeper, was manipulating fifty-foot-long steel joists with an electric hoist and was hand-painting them with red oxide.

Towards Chirifu a metal board showed the ground-plan of a former military airfield. I worked out the exact location and set out through a small wood to find it. In the middle of the wood where half the trees had been blown flat in the recent storm I found an abandoned shrine. I came out on the other side and stood on the edge of a wide and flat expanse of farmland. Bit by bit the airfield took shape in my mind. A shallow depression through the crops showed where one runway had been; another was now a farm track. A concrete building looked very much like the base of a control tower.

The airfield was about thirty miles from Nagoya and in my mind's eye I saw the Zeros taking off to attack the incoming American bombers the night in 1945 when Nagoya was totally destroyed.

I walked round the wood to get back to the road and met a seventy-year-old woman using a scythe on a stretch of undergrowth. In her twenties, she would have seen the airfield in

action. Pointing to where I had identified its remaining features, I asked if she could tell me more about it.

'No, that was not it.'

She turned and pointed in the opposite direction.

'It was over there.'

So much for my mental reconstruction of the past.

Later, I had the Japanese inscription on the plaque translated from a photograph. The airfield, it said, was built in 1945 when the war was going badly for Japan. It had belonged to the naval air force. Some six thousand young men came from all over Japan to train for a special mission to save their country. In the thirteenth century another war had been going badly for Japan. However, a typhoon arose and destroyed the invading Mongol fleet. This *kamikaze*, divine wind, proved that Japan was a country protected by the gods. The word for 'young' in the inscription on the plaque translated more literally as 'fresh-faced'. It was easy to imagine the nature of the special mission and just how many of the six thousand returned to base.

When I reached Chirifu it was already dark. One of the few people about was a youngish man standing by his folding bicycle. He was doing the Tokaido in weekend stages. We exchanged *meishi*, name cards, and I discovered that he was a graduate of the university where I was teaching.

Along the approaches to Chirifu (now called Chiryu) the old road is lined with pines planted by order of Nobunaga. Next to one of these is a commemorative stone and I made out the kanji for 'horse fair'. But in his depictions, Hiroshige's pine tree stands alone, in the middle of a field. I was not satisfied. My quest continued.

<h1>17</h1>

<h1>The dango pine</h1>

Chirifu • Narumi • Miya

'IT IS OBVIOUS that the Japanese, of both past and present, have taken particular pleasure in seeing with their own eyes sights known from their readings ... Some critics have even suggested that the Japanese have never looked at landscapes except across their preconceptions.'

Donald Keene's observation, I was beginning to suspect, applied to me. For days before I finally got there, Chirifu was not a town but the countryside scene that Hiroshige had drawn: paths running through grassy fields and meeting near a single tall pine tree. This was the setting for the uma ichi, Chirifu's famous annual horse fair.

I had found a monument to the fair the previous evening, but not the actual site nor the tall pine tree (or its successor). First thing in the morning I walked down the Chirifu (Chiryu) main street with the intention of asking anyone I met if they knew where the horse fair used to take place. One of the first shops I came to was a dry-cleaner's. Just outside the shop was a recess with flowers, a stone pillar inscribed 'Old Tokaido,' and a panel on which was reproduced Hiroshige's horse fair print. The shop's owner told me that there was a gentleman at the general store opposite who knew all about local history.

I went into the store. Kitchen utensils were displayed on one side, small grocery items on the other. In the middle was an old desk, a low table and a couple of chairs. A trim and fit looking, neatly dressed, elderly man with short well-groomed grey hair, greeted me in English.

'I'm looking for the site of the horse fair,' I said.

Gesturing towards a chair he invited me to sit down and gave me his meishi. He read the name for me: Imazu Zenzo. Above his name was a colour reproduction of the same Hiroshige print I had seen outside the dry-cleaner's. He took a sheet of paper out

of the desk and drew a map, marking the site of the horse fair with an X.

His grand-daughter came in and set two cups of green tea on the table in front of us. Sitting there in the middle of this cluttered and friendly shop I listened as Imazu-san told me about the history of Chirifu and about his own life. He was eighty-one and had once taught in a primary school. He had learned English by teaching himself and by corresponding with numerous pen-friends in the United States.

He went to a back room and returned with a cardboard box labelled in English 'Letters from America'. He opened it and passed me a sheaf of papers. The letters were from several states but most were postmarked Niagara Falls, New York. The earliest was dated 1930.

Imazu-san told me how it had all started. In 1927 an American philanthropist had the idea of fostering international friendship by getting young Americans to send dolls to children of other countries. Japan was targeted first because it had recently suffered a severe earthquake and the death in 1926 of the Emperor. Also, relations were at a low ebb due to Japanese immigration and new US laws to restrict it. Thirteen-thousand dolls, each with its own name, number and Japan-America friendship passport, were sent to schools all over Japan. (The return trade was somewhat unbalanced: fifty-eight dolls were sent from Japan to American schools.)

One of these dolls arrived at the school where Imazu-san taught and he wrote to the American organization asking to be put in touch with the sender. The result was an international correspondence involving the members of Mrs Inez McKellip's Sunday school class in Niagara Falls, NY.

I picked up letter after letter, some typed, some in beautiful handwriting: letters from a Harry Selby, Harriet M. Dunn, Emily May Dunn, Morris Charles Musgrave.

One letter acknowledged receipt of a Japanese doll but regretted that the doll's head had arrived broken. Another, dated 1930: 'I hope sometime it will be possible for you to visit our country. It does not seem so far away as it did years ago since transportation is so much better and faster.' (This in the days before the Boeing 747.)

A plaintive note is struck in a letter that says that the writer

has written three times but has had no reply.

'Please write soon.'

Another, dated 21 October 1932:

'I have been saving up newspapers telling about the difficulties between Japan and China. I shall send them this week.'

This was just a year after the Manchurian Incident, the first in a series of incidents that were to lead eventually to Japan's outright invasion of China and confrontation with the United States.

Imazu's correspondence with his friends in Niagara Falls came to an abrupt end in December 1941. In 1943 the Japanese government ordered the destruction of the friendship dolls. Of the original thirteen thousand only two hundred are known to have survived.

I left the store with the map Imazu-san had drawn for me and followed the Old Tokaido for a quarter of a mile or so back towards Okazaki. A side road took me to a modern bypass. The bypass rose to cross a railway line. I was now standing above a field of rice, yellow and ready for harvesting. At its edge was a slightly dilapidated farmhouse and a line of low ramshackle outhouses. Seemingly growing out of the roof of one of the outhouses was a tall pine tree. Beyond was the usual boxy concrete, TV aerial-infested chaos of suburban Japan.

I went down to the farmhouse and knocked at the door. Was this the site of the *uma ichi*, the horse fair? The farmer nodded vigorously.

'Yes, yes it is.'

I suspected his enthusiasm indicated the existence of other, rival, candidates.

Hiroshige had made this sketch in August, but the fair was held only at the end of April. Drawing from imagination he depicted the buyers as a gang standing together under the *dango matsu*, the conference pine. They have obviously been colluding. Their bids have been rigged. We sympathize with the sellers who are approaching, with their horse, as powerless individuals. They seem apprehensive.

I dropped in at the store to say goodbye to Imazu-san. He told me that he remembered the fair in his childhood in the 1920s. By that time it had become a general livestock market. Together we wondered if, by any chance, his Niagara Falls pen-friends were

still around and would like to re-establish contact.

On the way to Narumi I passed a barber's shop, a sign outside promising 'Presentment and Allurement'. A group promoting a festival co-opted me and presented me with a green cotton *tenugui*, a headband, useful for mopping up the sweat on this boiling hot day.

I stopped to look at the beautifully arranged *wagashi* (traditional cakes) in an Edo period shop. The shop was divided into two raised areas of polished wooden flooring with an earth runway in between that went deep into the recesses. I sat in the raised area and a cake was brought to me on a small square earthenware plate and served with a shallow bowl of frothy green tea, prepared as if for the tea ceremony.

At Narumi and its neighboring town, Arimatsu, not only was much of the Edo period architecture still in place, but the townspeople were still engaged in the industry that had begun there nearly four hundred years ago: the production of Arimatsu *shibori*. I had always thought of *shibori* as just a hot towel you were given when you sat down in a restaurant. In this case it denotes resist-dyed textiles. The art of *shibori* is usually described as tie-dyeing, but tying is just one of the many techniques involved.

Arimatsu first became famous for its cotton fabrics, resist-dyed in indigo to produce a characteristic dark blue spider's web design. Later, other vegetable dyes were introduced: safflower for reds and gromwell for purple. One theory has it that the *yukata*, the summer kimono, originated here.

Tracing the Old Tokaido in daylight was often difficult. In the dark I found it almost impossible. By 7.00 pm I was within striking distance of Miya but I was now trudging aimlessly along busy modern suburban roads. I had had enough for one day. Tomorrow I would try to locate what was left of the forty-first post-town, whose name meant quite simply 'shrine' or perhaps 'The Shrine'. But what shrine?

18

The seven-ri ferry

Miya • Kuwana

I WAS AWAKENED at dawn by an earthquake. My room was on the seventh floor and it was a minute or two before the swaying stopped. When the Big One comes, they say its epicentre will be somewhere between Shizuoka and Odawara. Every step I walked after leaving Shizuoka took me further away from the danger zone and it was now well over a hundred miles behind me. I felt there was nothing to worry about and went back to sleep.

After breakfast I left my hotel to try to find the Old Tokaido post-town called, simply, Miya ('shrine'). It was not marked as a town on any modern map. The easiest way, I decided was to go first to the shrine itself and then try to find the post-town named for it.

The first step was straight forward. I took a train from the station near my centrally located hotel and got off six minutes later at Jingu-mae ('Shrine Concourse') station, and from there I just followed the crowds. It was Autumnal Equinox Day and many young families were taking the opportunity to perform *omiyamairi*, presenting their newly-born children at the shrine and praying for the blessing of the *kami*, god(s).

This was a very special shrine, the second most important after the Ise Grand Shrine. Atsuta Jingu houses the Sacred Sword, *'Kusanagi no Tsurugi'*, one of the three sacred imperial treasures of Japan.

According to legend, Susano'o-no-Mikoto, god of the oceans, had fallen out with the goddess Amaterasu. Banished from heaven, he wandered round Japan until, at Izumo, he came upon an old couple and their daughter who were weeping. Once there had been eight other daughters but they had been eaten by an eight-headed dragon who that very night was coming for the remaining daughter. In return for a promise of the maiden's hand in marriage, Susano'o undertook to kill the dragon, which he

duly did by getting it drunk on saké and cutting off its eight heads.

In the dragon's tail Susano'o found a sword which he gave to Amaterasu who presumably passed it on to the priests of Atsuta Jingu.

I entered the shrine precinct through the massive wooden *torii* gate and made my way past a thousand-year-old camphor tree, through a gap in a mud-and-tile wall donated by Oda Nobunaga, to the main shrine building where two nine-year-old girls with bright red 'Hello Kitty' satchels on their back bowed their heads and prayed, palms pressed together against their noses and foreheads. A mother in a pink suit cradled her baby, clothed in a long white dress. They would not have looked out of place at a christening. Somewhere was the sacred sword but it was not my quest.

I left the shrine by another gate and very soon found myself at a temple near where I had left off walking the previous evening. In the light of day I was now able to read the notice which stated, in English, that one of the Ashikaga shoguns had held a *renga* (linked verse) party here in the year 1432.

A few minutes later I arrived at a canal, or rather a canal T-junction. A pier jutted out into the water. A wooden tower (bell tower? watch tower?) on a stone base stood to one side, near a stone lantern; next to this was a pillar bearing the legend *shichi ri no watashi*, the seven *ri* ferry.

Atsuta Jingu and Miya post-town have today been absorbed into the city of Nagoya. In Edo days, this section of the Old Tokaido stopped at Miya waterfront. From there a ferry crossed the top of Ise Bay to Kuwana. This was to avoid a long detour involving the crossing of three wide rivers. The shortcut was still a long seven *ri*, making this the greatest distance between post-towns on the Tokaido.

It is not so very long ago that the *ri* (3.93 kilometres or 2.44 miles), went out of use. Anyone over the age of seventy was able to tell me how many *ri* it was to the next town. A *ri* is divided into thirty-six *cho*, each about a hundred and twenty yards. If you walk down the main street in Ginza from Mitsukoshi, say, to Shinbashi, a new block and a new *cho*me start approximately every one hundred and twenty yards.

When I stood on the pier at Miya, a mother was picnicking

with her two little daughters. Hiroshige has two contrasting views of this scene. One shows a *torii* at the water's edge with a clear view across Ise Bay. Today, this is a wide channel with wharfs on both sides. As I looked in the direction of Kuwana a Shinkansen bullet train streaked across a bridge in the middle distance. In another print, rival teams of men hold onto ropes attached to running horses. They are taking part in the *uma oi*, the horse-driving competition. Although the action is centred on the horses and competitors the picture is dominated by the truncated portion of a tall *torii*.

An early admirer of *ukiyo-e* in general and of Hiroshige in particular was Monet. Apparently, he first came across Japanese woodblock prints in Le Havre where a local grocer used them to wrap cheese. (The prints had arrived in the port as packaging for ceramics.) According to the art historian Whitford, Monet once wrote that he admired the Japanese artists for their ability '...to evoke presence by means of a shadow, the whole by means of a fragment'. Some commentators have seen truncations in Monet's work similar to those in Hiroshige, in, for example, the series of paintings of Rouen Cathedral where the top of one tower and part or even the whole of the companion tower are cut off by the edge of the canvas. Our imagination is brought into play to supply the missing portion and that which is depicted on the canvas is immeasurably strengthened.

Today, there is no *torii* at the seven *ri* ferry: the nearest is about seven hundred metres away at the south entrance to Atsuta Jingu. Nor is there a ferry. With modern landfills and the growth of Nagoya's port, the distance to Kuwana by boat is now about the same distance as Dover to Calais.

I went through the motions of trying to find someone to take me across Ise Bay by boat and then, honour satisfied, took the Meitetsu Railway Line to the centre of Nagoya and then the Kintetsu Line to Kuwana. And when the train crossed the wide expanses of the rivers Kiso, Nagara and Ibi I did not feel I was cheating.

At the site of the old Kuwana ferry I sat on the high sea wall overlooking an estuary. Two boys were fishing about twenty metres away. One of them cast his line. The sinker, instead of plopping into the water far out in the estuary, hit my shoulder and the hook snagged in my shirt.

Nearby was a stainless steel monument to the five thousand and ninety-eight people who died in the flooding caused by the Ise Bay typhoon of 26 September 1959. Today was 25 September. (More rain falls in September than in the June-July 'rainy season', and, at least in Tokyo, the highest average rainfall is in the week beginning 23 September.)

A signboard showed the highly complicated route of the Tokaido through Kuwana. After making a series of right-angle turns I came to a junction. A man was watering the flowers in his garden. I asked him whether the right-hand fork, which looked the more authentic, was the old road.

'That's not the Old Tokaido,' he said. 'Follow me and I'll show you where it is.'

I knew he was wrong but not wishing to appear rude I went along with him, inwardly fuming as we wandered further away from the trail. Eventually, we came to a narrowish side road. There was a small temple and the road was lined with attractive old wooden houses. A wooden signboard said 'Old Tokaido'. Before saying goodbye we exchanged *meishi*. I read his job title. He was a manager in a local property development company.

19

Left for the Grand Shrines, right for the capital

Kuwana • Yokkaichi • Ishiyakushi

A MAN WAS expected to walk from Edo to Kyoto in about twelve days, a woman in about fifteen. With relays of couriers, a message could be sent in six, and a super-express system, operating day and night could do it in three-and-a-half. I had allowed seventeen days, but losing the way, stopping to talk, and the difficulty of finding accommodation, had all slowed me down.

It was now Tuesday. I set myself a new target of reaching the Great Sanjo Bridge in Kyoto by Saturday evening. I made an early start and took a taxi to the tall stone lantern near the banks of the Machiya River. I had stopped at this point late the previous evening. It had been dark and the old road had come to an end at the river bank. The *joyato*, the all-night lantern, had been lit and had been a source of comfort in what had seemed a godforsaken spot.

In the light of day it all looked very different. I now saw that there was a *ryokan* on the river bank. I knocked at the door to find out the cost of a night's stay for future reference and was invited to stop for tea and a cake. The proprietor told me that three students from Chuo University had walked the Tokaido a few months earlier and had stayed the night. It was their graduation trip and they had been travelling dressed in Edo period costume: saucer-shaped sedge hats and dark blue baggy leggings.

A feature of the old road, almost as common as the avenues of pines and the many shrines and temples, was the local primary school. In the Yokkaichi area, two in particular caught my attention. At the entrance to one there was a new-looking white stone slab inscribed, in English, 'Reach for the stars' in large Roman letters. Under this, in cursive handwriting, were the words 'Thank you' and a signature: 'Christa McAuliffe'. I surmised that the school had written to the American schoolteacher-

astronaut to wish her good luck for the Challenger mission and the signature was copied from the letter she wrote in reply.

The children, about two hundred of them, were engaged in a gymnastic display, in which the teachers seemed to be closely involved. Then I saw that one of the teachers was accompanying a child who had difficulty walking and was helping him do most of the exercises. A teacher saw me and explained that the school had a number of handicapped children and the policy was to integrate them wherever possible into the mainstream classes.

At the entrance to the other school there was a bronze statue of a boy in Edo period dress with a bundle of firewood on his back, reading a book as he walks. This is Ninomiya Sontoku, who made contributions in the early nineteenth century as an agricultural reformer, introducing, among other things, improved irrigation techniques.

At the Meiji Restoration, cultivation of moral character was made the prime aim of education, and Ninomiya was chosen as a model of diligence for his famed arriving at school with his contribution of firewood for the classroom stove after studying while on his way there. Bronze statues of him were erected at many schools and a song extolling his diligence was included in school texts.

Many teachers today associate these statues with the era of militarism and with current attempts to enforce the singing of *Kimigayo*, the national anthem, and the raising of the *Hinomaru*, the Rising Sun flag, at school ceremonies. The teachers' union was long hostile to both, arguing that they are tainted by association with Japan's role in World War Two.

During the war when metal for guns was running short, many of the statues were melted down. But I suspect that they are beginning to make a come-back.

Three of the schoolgirls saw me looking at the statue. One of them edged as close to me as she dared and stretched out her hand to touch the hair on my arm to see if it was real. The other two formed a chain to hold on to her while she performed this dangerous manoeuvre.

I had been looking forward to reaching Yokkaichi because it is the scene of my favourite Hiroshige print. A traveller, his cloak flowing, leans into the wind as he crosses a flimsy bridge. The wind is bending the reeds and branches. Another traveller is

running in the opposite direction to catch his saucer-shaped sedge hat, which is rolling away like a child's hoop.

Hokusai was considered better than Hiroshige at conveying the effect of wind, and this is Hiroshige's way of getting even by treating the wind as a source of humour.

Mitaki Bridge is still there today: a sturdy, boring structure, but I fancied I could see echoes of Hiroshige's bridge in the pattern of metal struts between the concrete supports. Beyond where once there were marshes and sedge, fishing boat masts and the waters of Ise Bay there now rise the cracking towers, flues and bulk storage tanks of a vast petrochemical complex.

In the 1950s Yokkaichi was a byword for industrial pollution and had its own disease named after it, *Yokkaichi byo*, a form of asthma brought on by the then lack of control over the release of chemical waste into the atmosphere.

Today it seems a pleasant enough place as industrial cities go. On the far side of Mitaki bridge is the Sasaiya, a 400-year-old shop still selling the best known of the Tokaido's *meibutsu* (famous local products). It is a type of *mochi,* a sticky rice cake with *anko* (bean jam) inside.

The name Yokkaichi means fourth day market. Markets were organized on a ten day cycle. Yokkaichi was where the market was held on the 4th, 14th and 24th day of the month. (West of Tokyo, a market was held on the 5th, 15th and 25th day of the month, hence its name, Itsukaichi.) None of this mattered to travellers on the Old Tokaido; for them, Yokkaichi was where the road forked. If you were on a pilgrimage to the Ise Grand Shrine, you turned left; if you were going to the Emperor's capital, you turned right.

I took the right fork (the stone signpost is still there – left: Ise; right: Kyoto, in Chinese characters) and followed the old road as it made its winding way up a hill. At the top I paused for breath and surveyed the scene. The sun had set. Behind me lights had come on all over Yokkaichi; to the right was a floodlit golf course; ahead a plume of thick black smoke rose high into the sky. This plume became like some kind of biblical beacon, always ahead of me no matter how far I plodded.

My map told me to turn right under a railway bridge at Ishiyakushi. I found myself on a muddy path in a field ending at a river. On the far side was the characteristic clump of trees that

I had begun to associate with old fording sites. I crossed by the bridge, reached the clump of trees and found a narrow road and at its side a group of stone Jizo. Losing the trail of the old road and using detective work to find it again was one of the great pleasures of this trip.

I came to a T-junction where two high-school boys stood chatting. I asked if the Old Tokaido turned left or right. The two boys consulted with each other, shook their heads and said they thought the Old Tokaido was on the other side of the river. I decided to pull rank in the Japanese education system.

'No. This is the Old Tokaido. The only question is, does it go left or right from here?'

They had no answer.

It was now dark and I was tired and hungry. I found a hotel. At dinner in the almost empty restaurant, sitting on a Chippendale-style chair and eating deep-fried *tofu* and grilled mackerel, I checked my map. The waiter was not very busy and I asked if he could help me locate the continuation of the old road. He went away and came back with a detailed local map. I showed him the T-junction where I had stopped.

'No, I'm afraid you were way off the track. This is the Old Tokaido over here on the other side of the river.'

And it was marked as such on the map.

To the two schoolboys, if you are reading this, which of course you are not, I would like to say: 'I'm sorry.'

20

The stone Buddha

Ishiyakushi • Shono • Kameyama

THE HOTEL SUN Route Suzuka deserved to be more fully occupied. My room was comfortable, the cooking was good and the service was impeccable. While I was waiting for my taxi (I had strayed a long way from the route of the Old Tokaido) I chatted with the hotel receptionist.

'Things are quiet at the moment but next month we are booked solid. We're near the Suzuka Circuit. The Formula One Grand Prix comes to Japan in mid-October and we've been fully booked for over a year'.

I asked the taxi driver to take me to the *ichirizuka* ('milestone') near Ishiyakushi. He radioed through to his control to find out where it was. I thought it was a proper *ichirizuka*, a large unmistakable mound with a tree growing out of it. Originally, they were pairs, one on each side of the road. Today, only one pair remains on the Tokaido, near Fuji City. Occasionally, there is only one mound and tree, but in most cases there is just a monument, if anything, to mark the spot.

I checked my map again and had to tell the driver that it was not a proper one, just a monument. In the end we settled for Ishiyakushi Temple, which nestles in a bend of the Tokaido. Legend has it that a priest who was travelling this way came upon a stone from out of which a light was shining. He recognized in it the spirit of a Buddha, and out of respect for the Buddha the road was diverted. Years later the saintly Buddhist monk Kobo Daishi is supposed to have engraved the image of the Buddha in the stone with his fingernail. Hence the town's name: stone Buddha. Yakushi is the Buddha of healing.

I was intent on finding the place where I had taken a wrong turn the previous day. The mistake was forgivable. The old road, as it leaves Ishiyakushi, goes under a railway line, under a bypass, back under the line and then over it at a small level-crossing.

Near the bypass was a pine grove where half the trees had been knocked flat by the recent typhoon. Behind the grove was the source of the plume of black smoke that I had seen all the way from Yokkaichi: a rubbish dump and a pile of burning tyres. Somewhere in the grove I should be able to find a short length of waste wood with which to mend my walking stick. The bottom twelve inches had broken off the day before. As a walking stick it was too flimsy to be really effective; it was just a piece of wood that I had found on the moss-covered stretch of stone pavement near Mishima. It had been useful for clearing cobwebs from my path. Later, I had tied a reflective yellow arm band to it and I felt safer with it on the road in the dark. It was a friend and a talisman.

I emerged from the grove with my piece of wood and came face-to-face with a burly middle-aged man and his wife and very attractive daughter. Embarrassed, I tried to explain what I was doing. The man went to his truck and came back with a pair of pliers and a length of wire and proceeded to attach the new length to my walking stick. He was the owner of the rubbish dump. His daughter was a piano teacher.

'What are you going to do when you get to Kyoto?,' the daughter asked. She looked wistful.

'Take the Shinkansen back to Tokyo.'

They laughed.

Two hours' walk later, I looked back towards Ishiyakushi. I could still see the plume of black smoke and, in my mind's eye, a fire burning.

I set off with my repaired walking stick and with renewed confidence in my route. Under the bypass, the concrete tunnel provided fabulous resonance for an impromptu Pavarotti solo. A few kilometres later the road was flanked by a high grassy bank. By the roadside there was an inscription on a stone monument and amongst the Chinese characters the only ones I could recognize were those for 'woman' and 'child'. I climbed the bank and looked down on the confluence of two medium-sized rivers.

Later that day I was told the story. The rivers used to flood with great frequency and loss of life. The villagers were forbidden to build a flood wall by the lord of Kameyama Castle because it could be a security risk. An enemy could advance under cover of the bank. At night, secretly, the women and children of the village, behind their leader, Kikuyo, built a wall, little-by-little,

over a period of six years. Eventually, Kikuyo was found out and condemned to death, but a reprieve from the lord arrived seconds before the appointed execution.

I had my lunch by the river, as usual sheltering under a bridge from the light but steady rain. I had a waterproof cape but it was always too hot to wear it. I would walk in the rain, get wet and dry out within an hour once the sun came out again.

Recently, I had made too many mistakes in following the path of the old road. I now checked more frequently and resolved to swallow my pride and trust my informants when they told me I was wrong. A newspaper delivery man on a motorbike led me back to the old road after I had strayed three-hundred yards in the wrong direction.

He was the only person in sight until, under a bridge, I came upon a group of primary school children. They were sitting on the curb, poring over a comic book. Their brightly coloured umbrellas and satchels lay scattered around them. When I reached them they leapt excitedly to their feet, surrounded me and fired questions. Where are you from? Where are you going? How old are you?

There were three boys and five girls, all dressed in white T-shirts, maroon shorts, and yellow baseball caps. Stitched to their shirts was a tab with their name, school year, and *kumi*, class. They were in the fifth year, third and fourth *kumi*. When I set off they followed behind me along the road Pied Piper fashion and then they caught up with me and we walked together until we came to their village, strung out along the Old Tokaido.

One by one they peeled off. 'That's Akiko's house.' 'This is where Jumbo lives.' The optician's daughter said goodbye as we passed a shop window full of spectacle frames. Our group got smaller and smaller until, finally, I was left alone with pretty, vivacious, sun-tanned, ten year-old Rumi-chan who kept me company for another three-hundred yards to the end of the village.

She was a mine of information about her school and neighbourhood, and when I asked if there was a hotel nearby she said there was one called the Dai-Ichi in Kameyama, the next town. We reached her house and said goodbye and I felt bereft.

The rain came down again but this time much harder. My quiet road came close to a crossroads on noisy Route 1. A large blue modern sign pointed the way to Sekigahara. In the year

1600, Tokugawa Ieyasu won the decisive victory there that made him shogun and eventually undisputed master of all Japan. On his way to the battle, had he passed right by the spot where I was now standing?

I reached the castle-town of Kameyama at nightfall. Two high school girls showed me the way down the steep hill to the Dai-Ichi Hotel. In the gathering dark I could see no sign of the castle and the town seemed gloomy and featureless.

I stood at the hotel front desk, dripping wet and dreading to hear the words I had heard so many times: *manshitsu desu*, 'We're full'. But all was well. Waiting for my key I looked round the foyer. On one wall there was a tapestry representation of Hiroshige's 'Kameyama'. Next to it was a poster, part of a local campaign to bring the magnetic levitation line, with its ultra high-speed linear motor trains, to Mie Prefecture. 'We like linear' the poster said, in English. If and when the line is built, towns like Kameyama will be on a super-fast direct route between Tokyo and Osaka, and they will regain some of the importance they lost when the Old Tokaido became a backwater a hundred years ago.

As I got nearer to Kyoto, the people seemed to get friendlier and the food tastier. At dinner I ordered the 1,200-yen *teishoku*, set menu. It consisted of eleven dishes on one tray, including *sashimi*, *tenpura* and *tofu*. It was delicious. Tokyo-dwellers find food bland and tasteless without lashings of salty soy sauce. People in the Kansai, the area I was approaching, prefer natural tastes: little salt, sparing use of *shoyu*, soy sauce. To make up for this lack of monosodium glutamate the emphasis is on freshness and variety of ingredients and painstaking care in presentation. The prettier it looks, the nicer it tastes. Synaesthesia. It seems to work. Besides, clear soup made from *dashi*, fish stock, with a slice of fresh cod and green herbs floating on top makes a pleasant change from the salty *miso*, bean curd, soup characteristic of Tokyo.

As I hung up my clothes in my room to dry, it occurred to me that I had passed through Shono without realizing it. 'Shono' is perhaps the best known of Hiroshige's Tokaido prints. A sudden rainstorm has caught travellers on the road. The palanquin-bearers are making slow progress uphill, while those going downhill are able to make a run for it. It had almost certainly been raining when I had travelled the same stretch of road.

I was now just a few miles short of the barrier that marked the border of the Kansai ('west of the barrier'). Beyond that was the last mountain range before Kyoto.

My goal was almost in sight.

21

Suzuka barrier

Kameyama • Seki • Sakanoshita • Tsuchiyama

THE TOKAIDO begins and ends with high mountain passes. In former days Hakone Pass guarded the approach to Edo, and Suzuka Pass the approach to Kyoto. From my hotel room I could see in the distance a range of blue mountains. They stood out crystal clear against the horizon. I wanted to be on the other side of those mountains by nightfall.

The manager of my hotel had taken the trouble to telephone round and locate a camera shop where I could buy the type of high definition colour transparency film I had been using and which was not readily available in Japan. The shop was on the top of the hill on the old road.

I climbed the hill to the shop and went on to visit what little remained of Kameyama Castle. Nearby was a shrine where the early morning peace was broken by intrusive sounds from two neighbouring schools. From one came the amplified droning voice of a teacher giving a lesson using a microphone, from the other the electronic rising tone *ping-ping-ping-ping* that precedes and follows every loudspeaker announcement made in Japan. (I once calculated that a Japanese *salaryman* commuting to work every day by train would, by the time he retired, have heard well over a million pings. Yet I have found few Japanese who have ever even noticed them, let alone found them irritating.)

The road took me by this school shortly afterwards and what had been an attentive class broke into chaos as the pupils, ignoring their teacher, rushed to the window to witness the phenomenon passing by.

'*Haro!*'

'This is a pen!'

'*Gaijin da*! Look it's a foreigner!', they shouted.

As in most towns the authentic route was difficult to follow, and I suspected I was now several streets away from the original

path. On the outskirts of the town an old lady was mixing wet clay and straw in her drive; she was doing something to her house but exactly what I could not tell. Beyond Kameyama, although there were few of the customary indicators, the road had the Old Tokaido 'feel'. From a bridge over Route 1 I could see it continuing in a broad sweep beside a river. This stretch was one of the most attractive of the journey so far. The carriageway stood proud, a few feet above rice fields on one side and the river on the other. Beyond the river there were foothills and then a range of blue mountains.

One of the very few buildings was a primary school. Japanese primary schools, unlike the junior and senior highs with their drab conformity, are usually colourful, cheerful-looking places where education is allowed to be fun. In the playground of this one there was a primitive, A-shaped wooden structure, thatched from top to bottom. I guessed it was a replica of a Yayoi-era dwelling. I stepped a few feet inside the playground to photograph it.

Within seconds a window flew open and a teacher leaned out, gesticulating angrily at me to go away. I put away my camera and trudged off. So much for 'internationalization'. What an example to the children, I thought. It would be no wonder if they grew up xenophobic. And yet that Yayoi hut had made it seem such an enlightened school.

I looked back resentfully and the teacher was still gesticulating, if anything more frantically. And then it dawned on me that she was waving at me, not to shoo me away but to encourage me to come into the school. I turned back, still not knowing what to expect, and went to the classroom window.

'If you have time, please come and say hello to the children in my class.'

I went round to the door. The children were sitting at their desks round three sides of a square. The teacher's desk was at the front in a corner by the window. The children sat very quietly, wearing shy smiles.

I had interrupted their lunch. On a metal tray in front of each child was a bowl of rice, *miso* soup, cucumber salad, a pencil-shaped roll of cheese, dried seaweed, yogurt and a bottle of milk. They carried on eating but seemed only to be toying with their food.

The teacher asked me to introduce myself. When I said I was

walking the Old Tokaido from Tokyo to Kyoto her face broke into a broad smile. She pointed to the end wall where the names of the fifty-three stages of the Tokaido were written on a long scroll to form a frieze. She showed me a work-sheet. It was a diagram of the Tokaido route. The children had to fill in the historical and geographical details.

One of the boys got up and offered me the seat at his desk. I squeezed into his place. Then one by one the children came to share their lunch with me: a girl gave me her milk, a boy his portion of cheese, another child her *miso* soup.

They were sixth-year pupils. In six months' time they would be entering junior high. The school's name was Kanbe Shogakko, (Kanbe Elementary School). I wondered if they would ever again be as happy as they obviously were in this school, in this class, with this teacher. The atmosphere of mutual love and respect was tangible.

Chimes rang out. It was the end of the lunch break. I got up to go and spontaneously five or six of the children came to shake hands and to say goodbye. One of them, the tallest – perhaps she was the class leader – gave me a small plastic tab and safety pin. Inside was a piece of white cloth with blue lettering. It gave the school name, and there was space for the child's name, year and class. Elementary schoolchildren wear them in school and on their way home. I pinned it to my shirt. Later that day the road was to become dark, lonely and a little dangerous, and I was to feel reassured knowing that if I got lost or had an accident someone might find me and take me back to Kanbe Shogakko.

I set off along the river bank towards the line of blue hills. The river was in spate and I was reminded of the photograph of the river on the cover of my LP of Smetana's 'The Moldau' and I tried to hum the melody.

The next stage was Seki. The word means checkpoint or barrier. The full name was formerly Suzuka no Seki. In the Heian Period, the barrier east of Kyoto that marked the boundary between the Kansai and the Kanto ('west/east of the barrier') was near Lake Biwa. In the Kamakura period the boundary moved further east. Barriers were established in three different places, one being at Suzuka. With the Tokugawa shogunate the border moved again. The Kansai remained where it was but the Kanto now began at Hakone barrier.

Seki today is a well-preserved Edo period post-town. A hundred metre stretch has been cleared of utility poles and resembles the tourist post-towns of the Nakasendo such as Tsumago, but in every other respect it is an ancient town functioning in a twentieth-century way.

The shops have narrow frontages but extend immensely far back from the road; this was to reduce liability for taxation: after all, the longer the road frontage, the higher the tax. One old shop is now a museum. When I visited it, a TV crew was filming the collection of Hiroshige prints, including the scene near neighbouring Sakanoshita of the *fudesute yama* 'Brush Throwing Mountain'. After this museum I walked past samurai residences, old craft shops, and a working blacksmith's forge.

Seki is on the road to Ise and at one end of the town there is the first of many *torii* gates leading to the Grand Shrines. At the other end is an ancient temple containing what is reputed to be the oldest statue of Jizo in Japan.

After Seki the old road petered out at a petrol station. With nothing else to go by, I followed a sign pointing to a hiking course. This brought me to a high, narrow, thickly-wooded ridge. From there I had a view of the whole of Suzuka plain and, in the other direction, of successive waves of blue, grey-blue and dark blue mountains. This surely was the scene that the illustrious painter Kano Motonobu had tried to depict at Sakanoshita. Despairing of being able to capture its beauty he had hurled his brush down into the valley below.

Later, I discovered that I had made a mistake and that I had actually been on the Brush Throwing Mountain rather than looking at it. I found the old road again when a wooden sign pointed to Suzuka Pass. The path was steep, and in many places had been washed away by the typhoon rains or was blocked by fallen trees. I was deep in a forest and it was so dark I could barely see the way ahead. I was beginning to get frightened and regretted tackling the mountain pass so late in the evening.

Suddenly, the path levelled, grew broader and I emerged into a field of tea plants where once again it was daylight. I was on the Kyoto side of Suzuka Pass. From here it was a long gentle descent all the way down to the ancient capital.

22

The six Jizo

Tsuchiyama • Minakuchi • Ishibe

THE WAY TO the top of Suzuka Pass had been dark, difficult and lonely. I had reached the summit with enormous relief. From there a grassy path led to a tall stone lantern whose black bulk was silhouetted against the last of the daylight. By the time I reached Tsuchiyama it was getting very late. I came to a *torii* gate. The shrine was hidden a long way back from the road but the path to it was lined with glowing lanterns. There was not a soul in sight. I was desperate to find someone who could tell me of a place where I could stay.

Eventually, I found a child feeding her dog outside her house. She called her father who directed me to the Marusa *ryokan*. From outside it looked like a very ordinary Japanese house. Several trucks were parked outside. Something told me I would not be welcome here, but on the contrary, the two elderly women proprietors greeted me as if I had been the only person they had been waiting for all day. Never were bath, dinner and bed so welcome.

At breakfast the next morning one of the two women saw me rubbing my knee. The previous day's climb had made an old injury flare up again. She produced a length of elasticized hose and a pack of poultices and showed me how to apply them.

On the breakfast television yet another typhoon was forecast. It was now over Okinawa and was heading directly for the Kansai area. Today was Friday. I calculated that I could be in Kyoto by the following afternoon, unless the typhoon got there first.

I left the *ryokan* with a hangover; my neighbour at dinner had plied me with beer and saké until late into the night. The proprietor sent me on my way with a gift of two *mikan* and a bottle of orange juice.

The *ryokan* was on Route 1. The Old Tokaido lay a hundred yards to the left and I went to explore the *shukuba*, the old post-

town inn area. Several of the buildings had explanatory signboards outside and I kept spotting the now familiar kanji for *ato*, 'ruins, remains, former site of'. Among the old buildings was a modern one, a savings bank. The time was a few minutes before nine. The young employees were standing in a semi-circle, their heads bowed and with that slightly contrived look of intensity on their faces that I used to associate with student Christian Union meetings. They were being talked to by a middle-aged man in a blue suit. This was *chourei*, a Japanese company's regular morning pep-talk.

As I passed a primary school the children were singing *The Happy Wanderer* under the direction of a teacher who looked briefly in my direction and turned away, slightly too quickly, as if she wished she had not seen me.

At Maeda Seicha, a shop selling tea, the owner showed me his collection of Edo period pottery connected with tea and the tea ceremony. He told me he belonged to a society for people interested in the history of the Old Tokaido. He gave me a copy of a booklet produced by one of the members, a doctor from Hamamatsu, who had done the fifty-three stages of the Tokaido in a 2CV Citröen at different times between 1960 and 1980. It was fascinating to see from his photographs how things had changed over a period of twenty years.

Further down the road, under an old barn roof, I discovered yet another antique and rusty hand-pumped fire engine. It did not look abandoned, but neither did it look as if anyone owned it. It had been used on one last occasion and time had just moved on.

When I had left the last house in Tsuchiyama behind me, the road became a farm track and then disappeared entirely and I ended up wandering in a circle round the edge of a rice-field trying to find an exit. A seventy-five-year-old woman bent double over a vegetable plot in a corner of the field directed me to a path through a cypress grove. This led back to the old road which soon came to an end at a river. The stone abutments of a former bridge were still visible on both sides.

Retracing my steps to the new bridge I got talking to a young man outside a metal works. There was a piece of beautiful old machinery in the yard; it consisted of a complicated set of wheels and shafts mounted on a wooden frame. It was for making rope.

I cranked the handle and the cogs meshed perfectly.

'Does this belong to anyone?' I asked.

'Why? Do you want it? It's yours.'

I promised to come back and collect it on another occasion.

The road continued to fall gently away from the mountains behind me, at times running beside a broad river, but more often between fields of yellow rice, in many of which mini combine-harvesters were at work. Typically, these were operated by husband-wife teams in their late sixties. Beyond the rice fields were groves of cypress and bamboo, and behind these successive lines of blue-green hills.

The road was narrow and quiet. It passed through hamlets where many of the houses had thatched roofs. Others had tiled roofs but with an extra short section of roof on the ridge to cover the chimney hole.

At Minakuchi the primary school was a child's paradise: there was an adventure playground, a pond full of carp, swings and slides and a swimming pool. The faces and initials of the 'class of Showa 55' —1980— were displayed painted on tiles mounted on a column.

A stream ran in a stone-lined conduit down the side of the road: two little boys were paddling in it. They had turned their yellow umbrella upside-down and had filled it with water and were using it to hold their catch of crayfish. As I passed their mother dropped by to pick them up and very reluctantly they got into her car.

Passing another primary school I was assailed with giggles and pointing fingers. The children crowded round asking questions but did not listen to the answers. The exception was one serious -looking child who kept me company on the road for a quarter of a mile. She told me her father was a professor at a university in Kyoto.

The road passed through a covered shopping mall. At the far end workmen were digging a hole. It was about six feet deep and I could see the different strata: clay, sand, gravel, asphalt. About four feet down was a layer of large round stones and I wondered whether this had once formed the Edo period surface.

At the far end of the town on the right-hand side of the road there stood a tall, narrow, whitewashed building. It was the width of a small garage but several times the height. From under the

massive door two stone tram rails emerged and ran up to the edge of the road. I asked at the shop opposite what the building was for. The shopkeeper took a set of keys off a hook and led me to the back of the building. We went inside and I was standing at the foot of a gigantic local festival processional float or *dashi*. It was like an outsize four-poster bed on wagon wheels.

Outside the town, in a wayside bamboo grove, six forlorn-looking statues stood in a row, each wearing a pink bib. They are the six Jizo, one for each of the six realms of reincarnation: heaven, humans, *ashura* or fighting demons, animals, hungry ghosts and hell. In front of each sat a candle and a plastic vase with fresh flowers.

By the time I reached Ishibe the evening rush hour was beginning. The old road had been peaceful all the way from Suzuka Pass. Now it was a rat-run in both directions. Several times cars travelling at speed forced me against the wall at the roadside. A car stopped ahead of me and a woman in her mid-thirties got out and ran to catch up with a boy who was striding purposefully away, head down. She grabbed his arm and tried to pull him back; it was a coaxing gesture, not angry or aggressive. The boys face showed sullen resentment. His mother pleaded and cajoled. A *kyoiku mama*, education mother, I decided. I sketched a scenario in my mind. She wanted to get him into a good high school and then into a good university. She wanted him to spend all his free time in *juku*, cram school, and doing homework. He wanted none of it.

In the village of Roku Jizo (Six Jizo) there was a fine wooden building from the early Edo period. A notice seemed to say that it was open to the public. When I knocked, the door was opened by an elderly man who asked me very politely if I could come back the next day. I said I would.

Ten minutes later, a car came towards me on my side of the road. It screeched to a halt within inches of me. I glared at the driver and ostentatiously stepped out of the way. The door opened. 'Sorry to frighten you but would you like a lift?' It was the wife of the owner of the house in Roku Jizo. Her husband was driving. They took me to a hotel and offered to collect me by car the following morning and to show me round the house. The Emperor Meiji had stopped there and there were many things to see, they said.

Approaching typhoons permitting, my visit would mark my last day on the Old Tokaido.

23

The old apothecary's shop

Ishibe • Kusatsu • Otsu • Kyoto

THE OLD TOKAIDO ends at the Great Sanjo Bridge (Sanjo Ohashi) in Kyoto. I had now walked some two hundred-and-eighty miles. Just twenty miles remained, thirty-two kilometres. Eight *ri*. An eight-hour walk.

I was back at Roku Jizo promptly at 9.00 am for the promised guided tour of the Wachusan Honpo. When I arrived, the owner, Osumi Yaemon, was taking down, one by one, the eight or nine wooden boards that served as shutters. Edo era buildings had short frontages onto the Tokaido; the longer the frontage, the more tax you paid. The Wachusan Honpo has an exceptionally long frontage, hence the many shutters. As each shutter came out, the room became brighter. I now saw the Old Tokaido as a shopkeeper would have seen it, looking out.

The building I was in was one of five establishments in the village that used to manufacture medicines for sale to passing travellers. One of these travellers, in the year 1612, was Tokugawa Ieyasu. During his visit he complained of a stomach-ache and the master of the house, an ancestor of the present owner, had cured it with one of his patent remedies.

As a result, the business prospered greatly, and a new and larger building was put up in the Kanei period (1624-1644). It is this structure which survives today and it has been designated as an Important Cultural Property. Its main room is vast, large enough for some thirty tatami. In a smaller room to the right of the main entrance was a thirteen foot-high wooden treadmill. A man would stand inside the wheel and turn it by walking. This wheel was geared to two other wheels, each four feet in diameter, whose wooden cogs turned a grindstone. There was a funnel for inserting herbs and other ingredients and the resulting powders came out of a spout at the side.

Osumi-san took me through to a smaller tatami room at

the rear, one side of which looked out onto a garden. It was divided from an adjoining room by four *fusuma* panels with ink paintings executed in 1770 by Soga Shohaku. This was the room where the young Emperor Meiji had paused on his journey between Kyoto and Edo in 1868, a journey that was to end the feudal age and usher in the modern, Western era.

I wanted to stay longer — there were many more things to see — but I was worried that I might not reach Kyoto by 5.00 pm. A Kansai-based newspaper had heard of my journey and I had been told that a reporter might be waiting at the Sanjo Bridge at about that time. On the way out I took a last look at the magnificent carved transom over the front door — turtles and whorls and interlacing foliage — and with mixed feelings (wanting to reach my goal but not really wanting the journey ever to end) set out on the final stage.

It was 10.00 am. Allowing time for lunch and other short stops, I had six hours to cover eight *ri*. I would have to walk very fast, much faster than I had walked on any of the previous days. By 11.30 am I had reached Kusatsu. Here the Old Tokaido joined up with the Nakasendo, the longer and more mountainous inland route between Edo and Kyoto which was used when flooding made the Tokaido rivers impassable.

I had considerable difficulty locating the old road. Only rarely was it signposted. I kept losing it and then finding it again by chance. Confirmation came in unexpected places: in a tunnel the walls were decorated with pictures of daimyo processions. Otherwise I went by the frequency of samurai residences, thatched houses and Edo era shops. Towards midday, I felt I was making good enough progress to allow for a coffee break. I went into a coffee shop called 'Friendly'.

'We're not open yet, come back in fifteen minutes.' I pressed on.

I crossed the Seta Bridge at the bottom end of Lake Biwa and should have turned immediately right along the wide modern road. Instead, I followed the more promising-looking narrow road leading straight ahead and walked for forty-five minutes before realizing my mistake. Panic set in as I hurried back, not knowing where I would find the right road.

I made for Otsu by any road I could. Each intermediate target took longer to get to than I had calculated. I had started to look forward to being interviewed by the reporter but now not only

was I missing long sections of the old road but I was losing all chance of reaching the Sanjo Bridge by 5.00 pm. I doubted whether the reporter would wait.

At Otsu I passed the site of the original Heian-period barrier between the Kansai and the Kanto. Encouraged, I increased my pace. The road started to climb, gently then more steeply. The surrounding hills crowded in. I overtook for the second time an elderly couple who were clearly doing the same trek as I. But I did not want to know this. I wanted to be the only one.

A tramline shared the narrow defile. I came to a bright red *torii* gate. Steep steps led up to the shrine. I climbed them and continued up beyond the shrine into a wood above it, and ate my last picnic lunch while I surveyed the Tokaido far below me. I watched as the elderly hikers plodded slowly uphill.

Back on the road, I reached the top of the hill expecting to see Kyoto lying before me but it was hidden by a bend in the road. I dropped in at a police box to check the exact distance to go. A teenaged boy was sitting slumped in front of the policeman's desk. The policeman was laying into him verbally. He paused to answer my question and them continued to berate the kid.

I stopped to look at an old spinning wheel outside a house. The front door was open and everyone came out to talk to me. A woman gave me a *fukusuzu* , good luck charm, for the remaining few miles of my journey. At the bottom of the hill I came to a working water pump. Three boys operated it for me so that I could slake my thirst. They were from Rakuto High School. Raku, they told me, was another name for Kyoto. Their school was in the east part of the city.

I looked at my watch. It was 4.15 pm. Panic again. How far was there still to go? I asked a man the distance to the Sanjo Bridge. Four kilometres, he replied. Four kilometres. Two-and-a-half-miles. One *ri*. The last *ri*. An hour's walk at most. But I was now walking faster than I had ever walked before. The adrenalin was flowing. From the top of the next hill I saw Kyoto before me. A signpost said Sanjo-dori, the avenue to the Sanjo bridge.

The road was busy and the pavements crowded but no one else existed. Film music started in my head. I looked right at a junction. There was the tall *torii* of the Heian Shrine. A middle-aged American couple turned the corner. I blurted out a greeting. These were the first Westerners I had seen since Toyohashi ten

days ago. The husband looked at me with thunderous disapproval. The crassness of my approach hit me the second I had started to speak. The adrenalin dried up instantly. The soundtrack died. They were still in the Muromachi era. I was making my re-entry into the late twentieth century. It was a doomed encounter.

And then suddenly a bridge. At the end of the bridge a group of people waiting: three cameramen, three reporters, my wife, her sister and niece. Cameras flashed. There was a short burst of applause. I had crossed the Great Sanjo Bridge. 124 *ri* and 29 *cho* from Nihonbashi, my journey was over.

The interview took place in a coffee shop. What was the best moment? What was the worst? Had I really walked the whole way? There was the problem of the missing ten miles between Fujisawa and Oiso when, in the early days of the walk and crippled by blisters, I had been forced to take the train. I decided this was not the time for a confession of guilt. My reply was vague. Inwardly I vowed to walk the missing section before the week was out. That way it would still count. My journey was not quite over.

24

Epilogue

I TOOK THE Shinkansen back to Tokyo. The typhoon that I had feared might block my arrival at the Sanjo Bridge bypassed Kyoto but severely interrupted rail traffic in central Japan. Many trains had been cancelled. This train was packed to overflowing. I stood all the way.

The features of my journey passed rapidly in reverse: the Seven *ri* Ferry, Lake Hamana, the great rivers Tenryugawa, Oigawa, Fujigawa, all of them now in flood; and for a split second I saw the old road at the point where it disappeared into a narrow concrete passageway under the Shinkansen tracks.

The following Sunday I fulfilled the promise I had made to myself in Kyoto: to walk the ten-mile section that I had missed between Fujisawa and Oiso and which included the post-town of Hiratsuka. It was not the only missing link. There was also Utsunoya Pass where I had gone through rather than over the mountain by way of an old and narrow brick-lined tunnel; there was a kilometre or so near Hamamatsu where driving rain, dangerous traffic, the dark and fear of not finding anywhere to stay had persuaded me to take the bus; and then there were the many stretches of old road that I had failed to find but presumably walked more or less parallel to. I had lost my way often, and had followed the advice of people who did not know the authentic route or I had not heeded those who did.

At Fujisawa I found the place where, crippled by blisters, I had decided to give up on just the second day out of Tokyo. I located a Hiroshige viewpoint that had eluded me the first time round, crossed the bridge that replaces the one featured in the woodblock print, and took the road through the area where the post-town once stood. The name Fujisawa, contrary to what I had always imagined, has nothing to do with Mount Fuji. Fuji here means wisteria, and I found the flower motif repeated in many places, even on the manhole covers set into the pavement.

I looked for but did not find the temple where a kind inn-

owner had paid to provide tombstones for his serving girls. Bought from their parents at the age of twelve, girls like these worked at the inns along the Tokaido until they were old enough for their real work: prostitution. By the age of thirty, they were dead, and with this notable exception, forgotten.

The road from Fujisawa is modern and I found little of interest. Instead I began to anticipate the moment when I would catch sight of Hiroshige's hill at Hiratsuka. It is quite unlike any other hill he has drawn on the Tokaido: tall, bulbous and rising with disconcerting immediacy from the surrounding plain. It belongs in China rather than in Japan.

I reached Hiratsuka as the sun was beginning to set. Ahead of me was a rounded protrusion, a bit like a plum pudding. If this was Hiroshige's hill it was a disappointment. The height was about right, but the shape was wrong. However, there was no other candidate and its position vis-a-vis the road was exactly right. In the woodblock print, Mount Fuji appears sandwiched between the hill and a range of mountains in the middle distance. This view was hidden from me by a wall of modern concrete buildings. To be certain of the identification I needed to be able to see that mountain backdrop.

I climbed the footbridge over the main road but it was not high enough. Near the bridge there was a fire-station. Its main door was open and a fire-engine stood ready. On top of the building there was a concrete platform and above this rose a sort of miniature Eiffel Tower with a bronze bell and trumpet-like loudspeakers pointing in all directions. If I could get permission to climb the tower I would have an unimpeded view.

I spoke to the fireman on duty. I explained awkwardly and long-windedly that I was trying to make a positive identification of a Hiroshige viewpoint and that the only way to do so was to climb to the top of the fire-station tower. It was a silly request and I did not really expect it to be granted. The fireman listened gravely, and then, without a word, went back into the building and started pulling a rope to lower the main door. As the horizontal metal sections clanked down a coloured picture, painted on the door, began to emerge. It was Hiroshige's view of the hill at Hiratsuka. I stood gazing, to the left at the reality, to the right at the reproduction.

Hiroshige himself had once been a member of a fire brigade,

the shogun's fire brigade. I had often imagined him climbing the fire watchtowers along the Tokaido in order to make his high viewpoint sketches. The fireman gave me permission to go up but warned me to be careful climbing the tower. I walked up the flight of stairs to the top floor and onto a balcony. From there I climbed a short but unprotected ladder. I was now at the foot of another ladder leading up the metal tower. I put one foot on the bottom rung, looked up and then looked down queezily at the street below, and decided that there was really no need to go higher. The view in the setting sun towards the mountains of Hakone was magnificent. Mount Fuji was hidden behind clouds but I already had my confirmation.

By the time I reached Oiso it was dark. The old road was lined with pine trees. There was no traffic at all. A large family piled out of one of the houses and into a car. A man and a woman remained behind waving goodbye. We got talking and they told me they were engaged in a battle with the local authority who were trying to upgrade the road. They were proud of their stretch of the Old Tokaido and they wanted to keep it just as it was: pot-holed, dimly lit, quiet and secluded. The council on the other hand wanted to resurface, put in modern street lamps and generally knock the road into shape.

What is to become of the Old Tokaido? A fifth, perhaps, has already been lost to the bulldozer, but most of the rest is still recognizably the old road. Almost all of it is untouched by tourism. Some local authorities have taken an interest in it and here and there there was evidence of the enthusiasm of local history societies.

It would be a pity if its pleasures remained hidden.

Yet it seems to me there are two dangers. Either it will remain largely forgotten and what is left will disappear as roads are widened and the *jiageya*, the criminal arm of the property speculators, get to work on the remaining old buildings. Or there is the opposite nightmare scenario where the Old Tokaido gets turned into a three-hundred-mile-long theme park.

My own wish is that it stay exactly as it is now: the few hundred yards of cedar-lined path and stone pavement at Hakone dedicated to the bus-loads of tourists; the long descent on moss-covered stone from there to Mishima where all day one perfect September Sunday I met just one other person walking;

the mountain passes at Satta, Utsunoya and Suzuka where the scenery was superb and where I was alone in the landscape; and my favourite parts: the place where the Old Tokaido passes through the middle of a petrol station forecourt, or at Numazu, where Hiroshige had drawn a band of strolling players walking under a harvest moon by the side of a river. Today at this spot there are a few scruffy shops and a surviving *ichirizuka*, the Tokaido equivalent of the milestone. The river is hidden behind a dank concrete wall, and on a roadside rubbish heap I found a discarded trophy, rusting and bent, Second Prize in the Shizuoka High Schools English Speech contest.

We are fortunate that Hiroshige was there to capture the Tokaido in the dying decades of the shogunate before the scenes that he knew were all swept away. It is his Tokaido that the world knows today. Before he died, of cholera, in Edo, he wrote his own epitaph: 'I have let my brush fall in the East, and depart on a journey through the skies to see the wondrous scenery of the Western Paradise.

My journey had taken me from what was once Edo towards the western capital. I remember with gratitude the people who, more than anything else, made that journey worthwhile: the chance companions of the road, the children, the many who offered hospitality, food and drink. It was rare that I entered a house or shop and left without some small gift.

And then there was the road, this beautiful, winding road, always ahead of me, behind me, once walked by samurai armies, by feudal lords and their thousand-strong retinues, by pilgrims on their way to the Grand Shrines of Ise, by mendicant nuns working part-time as prostitutes, by Hiroshige and the poet Basho, and by the Emperor Meiji when in 1868 he was called out of obscurity in Kyoto to journey to the new capital to begin the process by which Japan would become the second most powerful economy on earth. This lovely historic road, celebrated in songs and poems, was once the busiest road in the East, perhaps in the whole world.

Today's traveller walks alone, through wondrous scenery and a thousand years of history.

Select Bibliography

IN ENGLISH

On the Tokaido and Hiroshige
Addiss, Stephen. ed. *Tokaido: Adventures on the Road in Old Japan.*
University of Kansas, Spencer Museum of Art, 1980. This and
the following entry were published in conjunction with a
Tokaido exhibition at the Spencer Museum of Art, Lawrence.

_____.*Tokaido: On the Road: Pilgrimage, Travel and Culture.*
University of Kansas, Spencer Museum of Art, 1980.

Bicknell, Julian. *Hiroshige in Tokyo: the Floating World of Edo.*
San Francisco: Pomegranate, 1994. Edo and more: this
beautifully designed and illustrated book has a chapter on the
Tokaido, including seventeen prints from the Hoeido series.

Chiba, Reiko (ed.). *Down the Emperor's Road with Hiroshige.*
Tokyo: Tuttle, 1965. The version used is not the familiar
Hoeido version, but is still very attractive. Pocket size.
Short explanations of each print.

_____ . *Hiroshige's Tokaido in Prints and Poetry.* Tokyo: Tuttle,
1957. Small Hoeido Tokaido prints with short poems on the
theme of travel. Pocket size.

Forrer, Matthi. *Hiroshige.* London: Royal Academy of Arts/ Munich:
Prestel,1997. Book edition of the catalogue of the Royal
Academy's superb 1997 exhibition 'Hiroshige: Images of Mist,
Rain, Moon and Snow'.

Hoobler, Dorothy and Thomas. *The Ghost in the Tokaido Inn.*
New York: Philomel, 1999 An intelllegent adventure story for
young people. The story unfolds along the Tokaido in the
Edo era.

J*apanese Inn and Travel.* Tokyo: Japan Travel Bureau, 1990. Pocket size, highly illustrated guide to Japanese travel and hospitality. One in a popular series.

Jippensha, Ikku. (trans.Thomas Satchell) *Hizakurige or Shank's Mare.* Tokyo: Tuttle, 1960. Comic novel first published in 1802. Describes the adventures down the Tokaido of two amiable scoundrels, Yaji and Kita.

Lane, Richard. *Images from the Floating World: the Japanese Print.* New York: Putnam,1978.

Narazaki, Muneshige (adapt. Gordon Sager). *Hiroshige: The fifty-three* *Stations of the Tokaido.* Tokyo: Kodansha International, 1969. Highly readable essay, full of background detail.

Oka, Isaburo. *Hiroshige: Japan's Great Landscape Artist.* Tokyo: Kodansha International, 1992, paperback 1997. Various aspects of Hiroshige's work including examples of prints depicting both the Tokaido and the Nakasendo. Several high quality colour Hoeido Tokaido prints. The appendix has all fifty-five Hoeido prints in small, black-and-white format.

Robson, Lucia St.Clair. *The Tokaido Road.* New York: Ballantine Books, 1991. The Tokaido is the setting for this novel based on the story of the Forty-Seven Ronin.

Scott, Venetia. *Highways to Hiroshige.* Royal Academy, 1997. Interesting interactive introductory guide to the Academy's 1997 exhibition, produced by their education department. A series of questions help to focus on both the details and the overall impact of eight of the prints.

Starr, Frederick. *The American on the Tokaido: A Diary.* Tokyo, 1917. An account of a 1912 Tokaido journey by train and rickshaw.

Statler, Oliver. *Japanese Inn.* Tokyo: Tuttle, 1961. The history of Japan seen from the viewpoint of a real, historic inn on the Tokaido. A classic.

Tokuriki, Tomikichiro (trans. Don Kenny). *Tokaido: Hiroshige.* Osaka:

Hoikusha, 1963 (14th ed. 1993). A Tokaido journey by car, with the Hiroshige prints and the author's sketches and photographs. Pocket size.

Zacha, William. *Tokaido Journey.* Mendocino: William Zacha, 1985. Charming serigraphs depicting today's scenes at, or in the general vicinity of, each of the fifty-three stages, with annotations in English and Japanese.

Other Journeys in Japan

Booth, Alan. *The Roads to Sata.* Tokyo: Weatherhill, 1985. Booth walks from the top of Hokkaido to the southernmost tip of Kyushu. A highly original voice.

_____ . *Looking for the Lost .* Tokyo: Kodansha International, 1995. Three journeys, each on a different theme. The author's final work.

Downer, Lesley. *On the Narrow road to the Deep North: Journey into a Lost Japan.* London: Jonathan Cape, 1989. The author follows the path of Basho's classic journey, with the poet's haiku as illustrations.

Moeran, Brian. *A Far Valley: Four Years in a Japanese Village.* Kodansha International: Tokyo, 1998. (Originally published as *Okubo Diary* in 1985). The traveller sees a little of a lot of places. Moeran stayed put and saw a lot of one place, and describes what he saw and heard in minute and fascinating detail.

Richie, Donald. *The Inland Sea.* Tokyo: Kodansha International, 1993. An island-hopping journey, related by a fine stylist with a perceptive eye.

Japanese History and Culture

Bowring, Richard and Peter Kornicki (ed.). *The Cambridge Encyclopedia of Japan.* Cambridge University Press, 1993.

Collcutt, Martin, Marius Jansen and Isao Kumakura. *Cultural Atlas of Japan.* Oxford: Phaidon, 1988.

Japan: An Illustrated Encyclopedia. Tokyo: Kodansha, 1993. Lavishly illustrated, the Japanophile's bible.

Kaempfer, Englebert. *Kaempfer's Japan: Tokugawa Culture Observed.* Edited, translated, and annotated by Beatrice M. Bodart-Bailey. Honolulu: University of Hawaii Press, 1999. A fine new translation of this seventeenth century German scholar's account of his stay in Japan including a diary of his journey along the Tokaido in 1691.

Mason, R.H.P. and J.G. Caiger. *A History of Japan.* Tokyo: Tuttle, 1972.

Papinot, E. *Historical and Geographical Dictionary of Japan.* (1910) Tokyo: Tuttle, 1972.

Reischauer, Edwin O. *The Japanese.* Tokyo: Tuttle, 1978. Highly regarded view of Japan by this post-war US ambassador and academic.

Smith, Patrick. *Japan: a Reinterpretation.* New York: Vintage Books, 1998. As the title says, a re-interpretation, post-Reischauer, post-bubble.

IN JAPANESE

Atsumi, Hiroko. *Tokaido Gojyu San Tsugi wo Aruku* [Walking the Fifty-three Stages of the Tokaido]. Tokyo: NHK Shuppan, 1997. Two volumes, paperback. High quality reproductions of the Hoeido series with excellent contemporary photographs by Tsuchida Hiromi. Full of interesting and useful details.

Hayashi, Tadahiko. *Tokaido.* Tokyo: Shueisha, 1990. Distinguished photographer's coffee-table book of outstanding images taken along the Tokaido

Hiroshige Utagawa: Hoeido Tokaido Gojyusan Tsugi [Hoeido Tokaido Fifty-three Stages]. Tokyo, 1995. Exhibition Catalogue.

Imai, Kingo. *Konjaku Tokaido Doku Annai* [The Tokaido Now and Before: Independent Guide Book]. Tokyo: Japan Travel Bureau, 1994. Exceptionally clear Ministry of Construction 1:25000 scale maps, with old Tokaido route marked in red, place names in kanji.

Kodama, Kouta. *Tokaido Gojyusan Tsugi: Hiroshige kara Gendai Made* [The fifty-three Stages of the Tokaido: from Hiroshige

until the Present Day.] Tokyo: Dai Ichi Houki, 1985. Magnificent coffee-table book with Hoeido Tokaido prints, Taisho era sepia and modern colour photographs. Taisho era maps side by side with modern maps.

Kondo, Ichitaro (ed.). *Hiroshige's fifty-three Stages of the Tokaido.* Tokyo: Heibonsha,1960.

Morikawa, Akira. *Tokaido Gojyosantsugi no Jiten* [Dictionary of the Fifty-three Stages of the Tokaido]. Tokyo: Sanseido, 1986. A historical gazetteer rather than a dictionary including an account of their Tokaido journey by two Japanese housewives. Many black-and-white photographs and detailed Ordnance Survey style maps.

Ohata, Yoshio. *Watashi no egaita Tokaido* [My Tokaido in Drawings]. Shizuoka, 1994. Small black and white Hoeido prints with text facing the author's attractive sign pen drawings of modern scenes at or near the Hiroshige viewpoint.

Panoramic Magazine IS No. 75. *Teema Paaku Tokaido.* [Theme Park Tokaido]. Tokyo: Pola Research Institute, 1997. All fifty-five prints in full colour with excellent parallel contemporary photographs.

Tokaido Network no Kai, *Kanzen Tokaido Gojyusan Tsugi Gaido* [Complete Guide to the fifty-three Stages of the Tokaido]. Tokyo: Kodansha, 1996. No English but clear, detailed maps and will fit nicely in a backpack. Produced by members of the Tokaido Network Association.

Yamada, Yonekichi. *Dai Nishiki Tokaido Gojyu San Tsugi* [Large Brocade Fifty-three Stages of the Tokaido]. Tokyo: Naigai Taimuzu, 1977.

Yawata, Yoshio. *Tokaido*. Tokyo: Yuho shoten shinsha, 1987. Simple, outline maps: these were the ones used by the present writer. Plus commentary.

WEBSITES

A number of websites can be found by simply entering the words Tokaido or Hiroshige into a web search engine. The following is a selection of sites available in July 1999:

<http://www.csuohio.edu/history/exercise/vlehome.html>. This is an interactive 'visual literacy' exercise using the Hoeido series prints.

<http://j-entertain.co.jp/bellquiz/quizhome.html>. A cyber-journey down the Tokaido with information about the Hiroshige scenes. Quiz format.

<http://www.janitto.co.jp/INDEX.HTM Commercial site. The fifty-three stages presented by Nitto Ceramics Co., Ltd.

<http://www.kmsalon.or.jp/tokaido/English/link.html>. Page provided by Virtual Tokaido Project. Many links.

<www.rdt.monash.edu.au/~jwb/ukiyoe/hiroshige.html>. 'Jim Breen's Ukiyo-E Gallery - Hiroshige.'

<www.shizuoka.ntt.co.jp/wnn-c/tsushin/22jukuE.html>. The focus is on the 22 *juku* (post towns) that fall within Shizuoka Prefecture; provided by NTT Shizuoka.

<http://web.nwe.ufl.edu/~miodrag/jilly/highway.html>. 'Modern Landscapes in Japan - Tokaido Revisited'. 'Transformations of the Japanese landscape from Early Modern (Edo) to Post-war Japan'. An interesting site.

<http://troi.cc.rochester.edu/~boyj/ukiyoe/hiroshige.html>. 'Utagawa Hiroshige (1797-1858): The Fifty-three Stations of the Tokaido'. Includes prints from the vertical series.

<www.wbs.ne.jp/bt/ochakaido/index_e.html>. 'Green Tea Road'. Provided by Kawasaki Kiko Co., Ltd. Describes the Tokaido route as it passes through the green-tea fields between Kanaya and Kakegawa.

<www.across.or.jp/f-city/edo.html>. "The center of Tokaido 53 tsugi".
 Provided by Fukuroi City. As the 27th stage, Fukuroi takes
 pride in its central position: 26 stages to Edo, 26 stages to Kyoto.

<www.shoguninc.com/wwwboard/message4/118.html>.
 Connects to a site provided by a commercial ukiyoe gallery.
 Visitors exchange views about ukiyoe, in this case the
 (discredited) theory that Hiroshige copied Shiba Kokan.

<www.geocities.com/Tokyo/1537/>. The text of this site is in Italian.

Glossary

aka chochin: lit. red lantern, a small, reasonably priced drinking place
ato: remains, ruins
bakufu: military government with the shogun at its head.
bosatsu: bodhisattva, Buddhist saint
bosozoku: lit. speed tribe. Motorbike gangs who specialize in riding slowly and very noisily round residential areas at three o'clock in the morning
byo: sickness
chan: affectionate form of -san added to person's name
chaya: tea-house
cho: a distance of about 120 yards
chome: subdivision of a locality, a block about 120 yards square
da: is/are (familiar form)
daimyo: feudal lord
daimyo gyoretsu: procession of a feudal lord on his way to and from Edo
dango: conference, but with the connotation of collusion for the purpose of bid-rigging
dashi: tall processional float pulled through the streets in local festivals
de onna: outgoing women, i.e. women leaving Edo
desu: is/are (standard form)
e: picture
Edo: military capital of Japan under the Tokugawa shoguns. Re-named Tokyo after the Meiji Restoration of 1868
enka: wistful Japanese folk song
fukusuzu: good luck charm bell
fusuma: a sliding door
gaijin: lit. outside person. A foreigner
genkan: area just inside the front door of a house, where shoes are exchanged for slippers
genro: elder statesman of the Meiji era
Ginza: district in central Tokyo, named for the silver mint formerly situated in the area
gojyu san: fifty-three

Golden Week: a week in late April-early May, so called because it includes a string of national holidays

haiku: verse form consisting of 17 syllables in three groups with the pattern 5-7-5 and containing a seasonal word

hakama: traditional formal wear, consisting of loose-fitting trousers tied at the waist

hashi (bashi): bridge, ex. Nihonbashi

hidari: left

higashi: east

Hoeido: publisher of Hiroshige's first Tokaido series

honjin: lit. main encampment. Offical inn for daimyo

ichirizuka: the equivalent of a milestone; pairs of mounds sited either side of the road at one *ri* (3.93 kilometre) intervals and planted with a tree

irasshaimase: welcome called out to customers entering a shop or restaurant

iri deppo: incoming firearms

ishidatami: stone pavement

ishi: stone

ishidoro: stone lantern

jiageya: gangsters who specialise in intimidating homeowners to sell their property for redevelopment

Jimbocho: area of Tokyo famous for second-hand book shops

jingu: Shinto shrine

Jizo: one of the most popular of the bodhisattvas, protector of children, travellers and sufferers in general

kago: palanquin

kami: god or gods

kamikaze: lit. divine wind. Originally the wind that destroyed the invading Mongol fleet in the 13th century; aircraft and pilot in suicide attack

kana: Japanese phonetic writing system based on syllables

kanji: Chinese characters used in the Japanese writing system

Kansai: lit. west of the barrier. Today applies to area around Kyoto and Osaka

Kanto: lit. east of the barrier. Originally everything east of Kyoto. Today the area around Tokyo, east of the old checkpoint at Hakone

kita: north

koban: police box

konnichi wa: hello

ku: ward or borough

kumi: a class; a division of one year's school intake
kura: storehouse with fire-resistant earthen walls
kyoiku: education
Kyoto: lit. capital city. Capital of Japan 794-1868
kyu: old, former, as in kyu Tokaido, Old Tokaido
kyudo: lit. way of the bow. Japanese archery
manshitsu: fully booked (hotel)
masugata: lit. box shape. A series of right-angle turns in a road,
 arranged to slow down an approaching enemy
matsu: pine tree
meibutsu: famous local product
meishi: business card, name card
migi: right
mikan: Satsuma orange
minami: south
minshuku: Japanese equivalent of a B and B, except that dinner
 is provided as well as breakfast
miso: soy bean paste
miya: a Shinto shrine
NHK: Nippon Hoso Kyokai, national broadcasting corporation,
 equivalent of the BBC
Nihonbashi: bridge at centre of Tokyo; starting point of the Tokaido
 and the point from which distances are measured
nishi: west
notemburo: less common name for open air hot spring pool
NTT: Nippon Telephone and Telegraph
omiyage: souvenir of one's travels to give to friends and relatives
onigiri: rice ball, with pickled plum, fish or vegetable centre,
 wrapped in sea-weed
oshibori: small, moist hot or cold towel provided for guests at a
 restaurant
renga: linked verse. Participants take turns in adding to a poem
ri: measure of distance: =36 cho =3.93 kilometres=2.44 miles;
 roughly an hour's walk
rotemburo: open air hot spring pool
ryokan: Japanese-style inn
ryotei: traditional, high class, Japanese restaurant
sai: west (as in Kansai)
saka (zaka): slope or hill as in Gontazaka, Sakanoshita
salaryman: businessman (Japanese English)
-san: after a personal name, a title, equivalent of Mr, Mrs, Miss, Ms;
 it also means mountain, as in Fuji-san, Mount Fuji

sankin kotai: rule whereby daimyo had to spend alternate years in Edo

sekisho: checkpoint or barrier. The most important were at Hakone, Arai and, as the name implies, Seki

seppuku: ritual disembowelment

shibori: tie-dye (*shiboru* means to wring); *oshibori* is a hot or cold towel given to guests at a restaurant

shinkansen: lit. new main line. The bullet train

Shinto: lit. the way of the gods. Indigenous religion of Japan

shogakko: primary school

shoganai: common expression 'It can't be helped'

shogi: Japanese chess game

shogun: abbreviated form of title of supreme military commander

Showa: the Showa era (1926-89)

shoji: wooden sliding door or window, covered with translucent paper

shoyu: soy sauce

shukuba: lit. inn place. A post-town

soroban: Japanese abacus

suzumushi: lit. bell insect. Similar to a cricket

tanka: lit. a short poem. Verse form consisting of 31 syllables in five groups with the pattern 5-7-5-7-7

tatami: a straw mat with a soft top layer of woven rush, about six feet by three. The size of a Japanese-style room is measured by the number of tatami mats

teishoku: a set meal served on a tray

Taisho: era name (1912-1926)

Tempo: era name (1830-1844)

tenugui: Japanese towel, sometimes worn as a headband

teppan: iron plate on which food is cooked in front of the guest

to: east (as in Tokyo)

Tokaido: lit. Eastern sea road, main road from Edo (Tokyo) to Kyoto

Tokyo: lit. Eastern Capital. Capital of Japan since 1868

Tomei: Tokyo-Nagoya expressway

torii: gateway to a Shinto shrine

tororo: a thick soup of grated mountain yams

tsugi: stage or station

ukiyo: floating world

ukiyoe: lit. floating world picture. Woodblock prints depicting ephemeral, everyday scenes

uma ichi: horse fair

wabi sabi: a combination of two elusive concepts in Japanese

aesthetics. Austere beauty found in simplicity and imperfection

wagashi: Japanese traditional cake

waka: lit. Japanese poetry. Poetic form consisting of 31 syllables in five groups with the pattern 5-7-5-7-7 cf tanka and haiku

waki mizu: spring water

watashi: ferry

yakuza: Japanese gangster (lit. eight,nine,three: a losing score in card gambling, hence good-for-nothing; self-deprecating)

yama: mountain

Yayoi: era name (ca 300 BC - ca AD 300)

yukata: summer kimono

Two Facsimile Pages from
Author's Diary
[Towards Hakone]

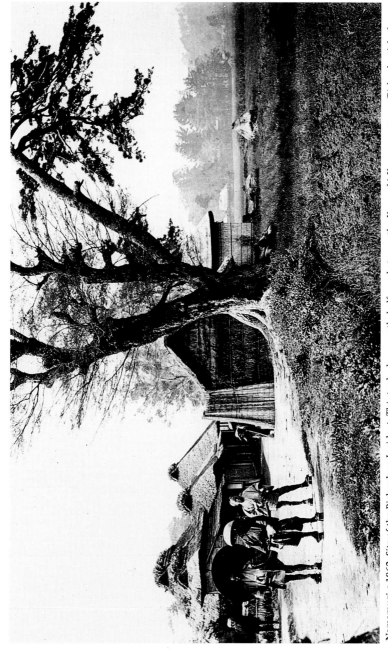

Namamugi c.1862. Site of the Richardson Incident. This took place exactly half-way between the Kawasaki Kanagawa stages. (Richardson's body was

Index